General Editor David Piper

Titian

Every Painting II

Terisio Pignatti
Art History Department, University of Venice
Translated by Judith Landry

Foreword by the General Editor

Several factors have made possible the phenomenal surge of interest in art in the twentieth century: notably the growth of museums, the increase of leisure, the speed and relative ease of modern travel, and not least the extraordinary expansion and refinement of techniques of reproduction of works of art, from the ubiquitous colour postcards, cheap popular books of colour plates, to film and television. A basic need – for the general art public, as for specialized students, academic libraries, the art trade – is for accessible, reliable, comprehensive accounts of the works of the individual great masters of painting; this has not been met since the demise before 1939 of the famous German series, *Klassiker der Kunst*; when such accounts do appear, in the shape of full *catalogues raisonnés*, they are vast in price as in size, and beyond the reach of most individual pockets and the capacity of most private bookshelves.

The aim of the present series is to provide an up-to-date equivalent of the Klassiker for the now enormously enlarged public interested in art. Each volume (or volumes, where the quantity of work to be reproduced cannot be contained in a single one) catalogues and illustrates chronologically the complete paintings of the artist concerned. The catalogues reflect as far as possible a consensus of current expert opinion about the status of each picture; in the nature of things, consensus has yet to be reached on many points, and no one professionally involved in the study of art-history would ever be so rash as to claim definitiveness. Within the bounds of human fallibility, however, every effort has been made to achieve both comprehensiveness and factual accuracy, while the quality of reproduction aimed at is the highest possible in this price range, and includes, of course, colour. Every effort has also been made to hold the price down to the lowest possible level, so that these volumes may stay within the reach not only of libraries, but of the individual student and lover of great painting, so that they may gradually accumulate their own 'Museum without Walls'. The introductions, written by acknowledged authorities, summarize the life and works of the artists, while the illustrations place in perspective the complete story of the development of each painter's genius through his career.

David Piper

Introduction

The diet of German princes, convened at Augsburg in 1548, ratified a decision that was to be crucial for Titian's future: it designated Philip II as successor to Charles V. During that winter the Spanish sovereigns had halted at Milan, and Titian had been summoned there to paint a first portrait of his future master (No. 295). According to the description in a sonnet by Aretino, this was a portrait showing the sitter 'in a fine posture of regal majesty', that is, possibly standing, and armed. It was sent by courier to Flanders. but then disappeared completely, since it seems clear that this was not the armed Philip II which is in the Prado (No. 322) - possibly a replica of it - because there exist documents referring to the delivery of the Prado painting in May 1555. In all probability the Prado work was used as a letter of introduction from Philip to Mary Tudor of England, who was to become his wife in 1554. At all events the Prado Philip II in Armour is an extraordinary work, in its haunting play of colour with the gold-damasked armour against the table covered with deep red velvet. The face, with its expression of arrogance mingled with a sinister melancholy, cruelly characterizes the young twenty-three-year-old who was to wield such limitless and absolute power, and in whose tormented person sensuality warred with a fanatical religiosity.

As if to confirm these contradictions, Titian's work for Philip II was, from now on, to separate into two strands: one distinctly erotic, inspired by profane mythological poesie, the other religious, devoted to the austere hagiography propounded and regulated by the Church. Particularly notable among the mythologies are several outstanding masterpieces produced for the occasion of the wedding with Mary Tudor, celebrated in

England. The Venus and Adonis in the Prado (No. 338), painted in 1553, is the prototype of a series which includes numerous replicas: with its warm, evocative sunset lighting, it uses the suffused sweetness of its colours to express the deeply sensual feeling suggested by the meeting of the two young lovers. In 1554. Titian finished the Danaë (No. 342), now in the Prado, making use of the same figure of Danaë as he had used in the canvas painted for Ottavio Farnese (No. 255), but replacing the Cupid by an avid old woman collecting the shower of gold coins which are symbolic of her rape by Jove. Looking almost larger than life, her flesh pink against the white sheet, the shapely Danaë is reminiscent of Michelangelo (his figures of Dawn or Dusk on the Medici tombs) while the colour, which is dissolved into flashes of light, seems to reflect ecstatic physical abandon. The painting undoubtedly represents a high point in the career of the painter, mature as he then was: and other canvasses of the 1550s bear witness to the freshness of his approach to profane subjects: one example of this is the Venus at her Toilet, with two Cupids (No. 345) in Washington, which presents us with an image of triumphant Venetian beauty, only marginally tinged by Mannerist traits, for example, the red-green of the hanging in the background, or the elegant play of the two Cupids holding up the mirror. His female portraits, too, have an echo of the sensual power inspiring these paintings, and include the marvellous portrait of Lavinia (so called) as Bride with a Fan (No. 348) in Dresden, the Venetian Girl (No. 347) in Washington, and the Lavinia (so-called), with a Tray of Fruit in Berlin (No. 349): where dresses in a coral pink, light green and a superb golden-brown brocade give, each to its own compositions, its particular and positive splendour.

In his male portraits, however, Titian seems still to be relying on the established schemes of the previous decade, at most extending the structural range of his compositions. Often, the figures are seated in magnificent armchairs, as is the Philip Seated wearing a Crown in Cincinnati (No. 360), the Ludovico Beccadelli in the Uffizi (No. 331) and the Portrait of Archbishop Filippo Archinto in the Metropolitan (No. 362). This device allowed Titian to give greater emphasis to certain features of the figure, the red capes and white robes of the prelates or the damasked silks and gold chains of the princes. Sometimes Titian's strong dramatic sense prevails over the decor and this gives us, in the Thyssen Francesco Venier (No. 363), a powerfully expressive image of the old, sick doge. There the gold of the cloak seems to be in painful contact with the sharp rose of the curtain. The figure of Cristoforo Madruzzo in Sao Paulo (No. 330), painted in 1552, plays on a similar contrast of apparently clashing colours - the black of the clothing, the green velvet of the tablecloth and the red of the hanging. The unity of the masterpiece is, however, restored by the cold, frontal light.

The end of the sixth decade of the century was devoted to a very important series of religious works, many of which were intended for the court of the 'most Catholic king' Philip II. They were preceded by a huge painting on which Titian worked over a long period (from 1551 to 1554), the Trinity now in the Prado (No. 352). In accordance with a formula which was to be particularly successful in the Baroque period, various donors appear in the work alongside the religious figures: Charles V, the Empress Isabella, Philip II and Queen Mary. If it cannot truly be called a masterpiece, this great canvas demonstrates that the painter could, if necessary, adopt the formulas of a bigoted court, controlled by powerful 'confessors'. Titian's treatment of religious themes was much more successful when he could have free recourse to his own imagination. At times his religious feeling was to find expression in settings exceptionally filled by light, as in the Annunciation in San Domenico Maggiore in Naples (1557, No. 372) or in the Pentecost in the Salute in Venice (No. 373). Here, rays of light surround the figures and give them spiritual value: the angels melt away into flickers of gilded light, the Holy Spirit sends down a rain of silver on the apostles, who appear trembling and possessed. Similarly, in the Crucifixion at Ancona (1558, No. 377) and the Christ on the Cross in the Escorial (1559, No. 382) the figure of Christ stands out from the dark bluish background, while shafts of light illuminate the dramatic gesturings of the pious women, or give a sinister quivering quality to the landscape of Golgotha, which becomes a landscape of death. The masterpiece of the period is undoubtedly the Martyrdom of St Lawrence in the church of the Gesuiti (No. 380), on which Titian worked between 1548 and 1559. His tendency to set his dramatic scenes at night, emphasizing their movement through the dynamism of the sources of light, seems completely developed here. The use of colour, which is teased out in soft brushstrokes or thickened into carefully calculated touches, also seems to be new. In short, here, at the beginning of his sixties, Titian seems to be embarking on what critics have come to identify as his last period,

During his last period, Titian's activity as a draughtsman assumed a dramatically pictorial character; he used both charcoal and pen to create strong contrasts of light and shade, as can be seen in the Mythological Couple Embracing (Cambridge, Fitzwilliam Museum) and in the Landscape with Nude Woman Sleeping, and Animals (Chatsworth, Duke of Devonshire's Collection).

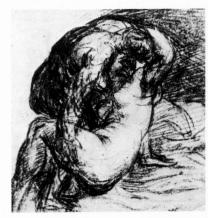

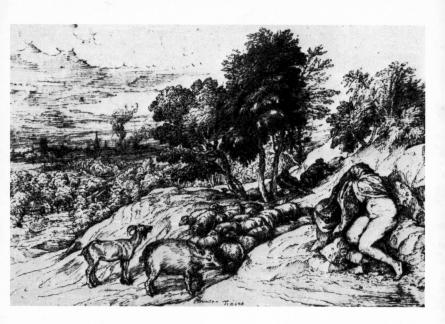

characterized by a mood of intense expressiveness. With Titian, there was no question of the effects of light being used as an end in themselves – as one sometimes finds. for instance, in the works of Tintoretto or the Bassano family. In Titian's painting the effects of light are closely bound up with the dramatic process of expression. St Lawrence is burning in the flames of martyrdom, and he is himself becoming flame and colour in a sense that is at once mystical, spiritual and formal. He is symbol and sacrifice, an agonizing reality and a celebration of the pure values of form. Nor is it totally satisfactory to see this new style of Titian as fitting into the canons of Mannerism, however reasonable this suggestion might be when considering the experiences of the previous decade. In point of fact there is an existential presence prevalent in Titian's artistic ideals, an experience of feelings which go well beyond the invariably contrived elaboration of the maniera. One example of this can be seen in the painter's ability to impart a wave of near madness to the group of disciples in the Entombment sent to Philip II in 1559, and now in the Prado (No. 383). Never, till that moment, had the sense of death and desperation been translated so forcefully into movement and colour.

Death and despair were feelings very real to Titian during those years. The year 1556 had seen the death of Aretino, Titian's companion for thirty years and his tireless champion in the courts of the powerful. In 1558 the Emperor Charles V died, a monarch to whom Titian was bound by affectionate gratitude and possibly by a bond of sympathy for the wretched events which had dogged the emperor's last years, in the solitude of the monastery at Yuste. In 1559 it was the turn of Titian's brother Francesco to die, a modest collaborator in so many artistic undertakings and an uncomplaining companion. Titian also had other reasons for worry and grief, in particular the attempted assassination of his son Orazio by the sculptor Leoni, who tried to lay hands on the two thousands ducats Orazio had just received in Milan as payment for the paintings sent to Philip II.

Tragic events, obscure presages of doom, saddened and haunted the now seventy-year-old Titian. Their weight can sometimes be felt in the beseeching letters he sent to a king, who gave no acknowledgement of the despatch of even the most stupendous paintings (*... it is now seven months since I sent your Maiesty

the paintings which you commissioned from me...') or did not trouble to ascertain if payments were made ('...I do not see how I can ever hope to obtain these payments'...). The thought of death was woven into all his letters ('before I die... now towards the end of my days...this my extreme old age... this stricken body... the calamity of the present times').

The nature of many letters and documents dating from the end of his life have given rise to the myth of Titian's greed for money, and his miserliness. But it is surely quite clear that Titian was completely within his rights in demanding payment for his paintings - for which he undoubtedly remained in credit rather than in debit with the majority of his noble patrons. At all events, what is incontrovertible, and what interests us because it is closely linked to his artistic productions, is the sense of increasing depression and melancholy by which he was overcome, a sort of physiological premise for the twilight attitude which seems to be at work within his style itself. This had nothing to do with failing sight or unsteadiness of hand, as an overpositivistic school of criticism has imprudently claimed, but rather with the desperate and conscious rejection of life that was growing in the painter's increasingly weary The Berlin Self-Portrait (c. 1562, soul No. 400) documents this moment most tellingly. The intervals in which Titian seemed miraculously to recover the creative inspiration and vitality of happier times were becoming rarer, though he could still sometimes respond to the ever-pressing requests for poesie for the secret camerini of Philip II. In 1559 he despatched the two great histories of Diana, now in Edinburgh (Nos 386 and 387), to Spain; a few years later he sent the Perseus and Andromeda (No. 407) and the Rape of Europa (No. 408). It is interesting to compare the mood of the first two paintings intentionally erotic and still thematically linked to a somewhat outmoded classicallyoriented culture – with contemporary Venetian painting between the 1550s and 1560s. The painter closest to these profane attitudes was possibly Veronese, working on the frescoes in the Villa Barbaro at Maser. But it seems very unlikely that there was any genuine point of contact between their Olym-

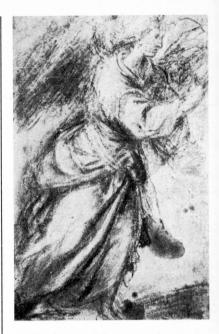

Angel of the Annunciation, charcoal drawing, heightened with white, on blue paper (42×28) (Florence, Uffizi, Gabinetto dei disegni e delle stampe).

pian beauty, emotionally cold and intellectually detached, and the deeply dramatic, and existentially involved, mood of Titian's fables. In the first of the two canvasses to-day in Edinburgh, Actaeon imprudently discovers Diana and her nymphs bathing, and his presence is like a hot stormy wind suddenly unleashed, agitating the great crimson drapery against the green of the fountain. The rosy bodies of the naked nymphs weave between light and shade, and the shadow intensifies the modelling of the flesh, skimming it with a burning, sensual breath. There is surely nothing remotely similar in the equally naked but statuesque beauties of Veronese's Sala dell'Olimpo at Maser. There is a world of difference between the shimmering colour created by Titian's half-light, and the crystalline limpidity which clothes Veronese's forms in a transparency like that of an aquarium. Nor does there seem any possible comparison with Tintoretto, although he, too, often painted nudes during his youth, for instance in the *Venus and Mars* (Munich) or the *Susannah* (Munich, Louvre and Vienna). Those images stress the dynamic and the linear and are intentionally remote from Titian's abiding vitality, which was to be far more tellingly taken up – in due time – by Rubens in the *Judgment of Paris* and by Velázquez in the *Rokeby Venus* (London, Wallace Collection and National Gallery).

Titian thus kept close links with the themes being considered in the first decades of the century, retaining his own particular brand of classicism, inspired both by antique statuary and by its reformulation of the time of Giorgione. But at the same time he knew how to breathe new life into otherwise antiquated iconographical themes (as one can see by comparison with the results when they pass into the hands of lesser painters, from Palma to Paris Bordone), a vitality which was connected with his hard-won emotional maturity, with the sadness of everyday living, the bitter consolation of the senses, his isolation in the world of memory and art. In our opinion this also explains the extraordinary quality of certain of his conceptions which, as in the Diana and Callisto at Edinburgh. anticipate, almost by centuries, later developments. They foreshadow the world of Watteau's Fêtes galantes or the decorative taste of a tapestry designed by Boucher, even more than they foreshadow Rubens. Titian also turned back to his past in his imagination - but with what immense expressiveness! In his Venus and Cupid with a Lute Player (No. 402) at Cambridge, and in the contemporary version in the Metropolitan (No. 403), he makes, in fact, a virtual return to the Venus and Cupid with an Organist (No. 293) of some ten or more years earlier. but the rarefied and dazzling light in the background, and a certain sfumato softness in the chromatic touch, belong rather to the style which had developed between the end of the 1550s and the beginning of the 1560s. Thus the replicas of the Venus and Adonis of Philip II (see Nos 404 and 405) have a value quite independent of the original: that with a cupid added, now in the Metropolitan (No. 404) and the one in the National Gallery in Washington (No. 405) are much denser and

softer than the earlier version, their impasto quivering with colour. Around the year 1560 Titian then devoted himself to three outstanding masterpieces. The Boston Rape of Europa (No. 408), completed for Philip II in 1562, carries broken brushwork still further: the forms seem as if continually striving to dissolve and reform in the misty atmosphere. It is rightly related to the Perseus and Andromeda in the Wallace Collection (No. 407). There, the eerily rippling waters are agitated by the approaching monster. while the beautiful figure of the woman makes her attempted escape in a diagonal, fleeing, as it were, towards the corner of the canvas. Lastly, we have the Death of Actaeon in London (No. 409), which was being worked on for Philip II as early as 1559 but which was undoubtedly finished later, extraordinary for the sulphurous flicker of light around the figure of the goddess, who is aiming her bow at Actaeon, mercilessly being savaged by the dogs.

These works established what was to be the expressive style of the last decade of Titian's work. Its reassessment is the pride of modern art historical criticism, possibly the most significant event in the history of Titian scholarship. Indeed, in sixteenth-century writings, as is well known, the late works of Titian had been regarded somewhat disdainfully. The Tuscan critic Vasari expressed explicit doubts about the *perfetione* ('perfection') of the *Annunciation* in San Salvador

The artist's signatures in the paintings here catalogued as Nos 320 and 344.

TITIANVS · RQVES · CAS

(No. 420), probably only just completed when he visited Venice in 1566, and also of other comparable works, since they appeared to him to be 'executed with bold, sweeping strokes, and in patches of colour', although he intelligently admitted that 'they appear perfect from a distance'. The Romano-Tuscan prejudice against the Venetian emphasis on colour, which apparently ignores design, long remained at the root of the incomprehension of Titian's late style. It continued throughout the whole neoclassical period and, summed up in the highly critical judgment of Cavalcaselle (1877-8), during the more positive 19th century. Yet a relevant page of Boschini (1674) recorded the invaluable evidence of a pupil of Titian's last years. Palma Giovane: evidence which should have served to explain Titian's highly original late style. When writing of the ageing Titian Palma recorded that he: 'laid in his pictures a broad mass of colours which served, so to speak, as a base' for successive stages of the painting, which was continually re-worked 'with bold strokes. with a brush heavily laden with colours; at one time with plain red earth for, as one says, the half-tones: at another with white lead: and with the same brush, dipped in red, black or yellow, he worked up the light parts; and, from these four strokes, by means of the highest Art, he could create a remarkably fine figure ... 'He continued: 'But the final touches he softened, occasionally modulating the highest lights into the half-tones and blending one tone into another with his finger; sometimes he used his finger to dab a dark patch in a corner as an accent, or to heighten the surface with a bit of red like a drop of blood. And thus he brought his figures to perfection; and in the last stages he used his fingers more than his brush.' It was not until the Impressionist painters won their battle against 19th-century academism that there was any appreciation of these perceptive words; it was then that the critics, having grown accustomed to their fresh approach, could look with new interest at its prefiguration, in Titian's late style. This was the discovery of Berenson (1894), confirmed by Dvořak (1927-8). Meanwhile Fry (1924) compared Titian's style significantly with that of the late Renoir, and Longhi (1925) and Pallucchini (1969) described Titian's development as progressing from the 'chromatic classicism' of his early works, through an unacceptable revolutionary Mannerism, to its final outcome in a 'chromatic alchemy' which – with due regard for chronology – was defined as a 'magical Impressionism', because of its complete visionary originality. It was as if Titian had delved into some unknown depth to come up with an entirely new cosmic substance from which to reconstruct his own hard-won poetic vision.

The Annunciation in San Salvador in Venice may date from the beginning of this last decade of Titian's life, which starts in 1566 and ends with his death. Its frenzied brushstrokes seem to enflame the setting of the Madonna where the angels hover in the smoky air. Titian's vehement touch dissolves and recomposes the forms, which build up a new principle of design. This (as in the study for the Angel in the Uffizi) has been freed from the sculptural and linear assumptions of the Romano-Tuscan tradition, in order that, through the interplay of repeated touches of tone and colour, pictorial form may be arrived at organically. One can well understand the frequently adduced parallel between this masterpiece of deeply felt expressive tension, and the late works of Rembrandt.

There are other works which, technically stylistically, correspond well Palma's description. In the Munich Madonna (No. 413) the figures, gleaming like phantoms in the foreground, are drawn from the shadows of a firelit landscape. Similarly, the little Madonna in London (No. 431) recalls, with its delicate and melting impasto, the lovely Madonna and Nursing Child in the parish church in Pieve (No. 430). There is also expressionistic almost reworking (No. 432) of the Entombment previously supplied to Philip II (No. 383), also in the Prado; and the reworking (No. 436), with its even greater insistence on the effects of light, of the Martyrdom of St Lawrence (No. 380) for the Escorial, sent to Spain in 1567.

One might have thought that a period so intensely devoted to religious subjects, treated in such a wide, almost wild range of colour, would necessarily have precluded any other imaginative preoccupation, and have limited Titian's creations to a single pathetic mode. But the ageing painter's extraordinary cre-

ative capacity is confirmed by the existence of many paintings, executed during the same period, which show an unlooked for independence in the treatment of mythological and profane themes. Thus we find a resumption of portraiture in the portrait of the Roman antiquary Jacopo Strada in Vienna (1568, No. 450). This is executed in scattered strokes, in browns and light ochres, against which the black velvet doublet with its red sleeves and the cloak of silver fox fur over the shoulders, stand out sharply. Close attention to the numerous details which indicate the subject's profession (the medals, the statuette, the cornice and the books) does not lessen the impact of the characterization of the face, whose gaze is directed questioningly out of the picture: a peculiarly modern device of a psychological intensity worthy of Shakespeare. And indeed the unassuming Self-Portrait in the Prado (No. 458), with its old man's immobility, the eyes with their reddened lids gazing fixedly, the tremulous lips, the slightly unsteady hand clutching the still prestigious brush, seems inspired by a Shakespearean awareness, which is painfully human.

Lastly, there are, at the end of the seventh decade of the century, a number of mythological compositions: the Cupid Blindfolded in the Borghese Gallery (No. 438) with its partial replica in Washington (No. 439) is surely especially happy and characteristic of that 'unfinished' style which sometimescaused critical incomprehension. This painting, admired in Rome by van Dyck, who made a copy of it in his sketchbook, seems to envelop its mythological figures in a wave of crimson and gold: they look back to the happier style of earlier decades, but are now marked by something approaching existential anguish in the broken handling and the shifting colours.

Between 1568 and the beginning of the 1570s Titian also painted a series of figures of Christ, pious images of enduring pathos. At least three of these – the *Christ Blessing* (No. 452), the *Ecce Homo* (No. 454) and the *Christ carrying the Cross* (No. 456) – now in Leningrad – come from the Barbarigo Collection, which brought together the last works bequeathed by Titian, disposed of after his death by his son Pomponio. These are comparable, in theme and style, with another

Christ carrying the Cross in Madrid (No. 455), and with The Tribute Money in London (No. 457), sent in 1568 to Philip II for the Escorial. It is fascinating to imagine these small canvasses, all together in Titian's studio, being turned and re-turned to the wall, as was his custom, then worked on again, modified and retouched until they reached perfection; and to imagine the exacting Titian keeping them there until the last days of his life. They were in fact found together – a series of anguished faces silenced by pain – in his studio after it had been left empty for the last time.

The artistic relationship between Philip II and Titian, too, lasted until the very end: the famous letter in which Titian sums up the list of the latest consignments dates from 27 December 1574, while the one in which he makes his last request actually bears the date 27 February 1576: 'being already reduced to a very serious state and furthermore being in great need, in all humility I come to you to beseech you that, with your usual pity you might deign to give your ministers whatever order may seem most expedient for the relief of my needs...' Among the last canvasses sent to Spain was one of Tarquin and Lucretia, now in Cambridge (No. 460), and once again one is amazed by the quicksilver movement of the scene, which is emphasized by a very rapid, almost flickering play of light over the foreground. There is a probable first version (No. 459) of the work in the Academy in Vienna, executed with those 'dabs' which Palma saw as deriving mainly from the frenetic touch of the artist's fingertips. Two other works of the early 1570s, the Adam and Eve now in the Prado (No. 462) and the Stoning of St Stephen now in Lille (No. 464). are more monumental and oddly sculptural. possibly because they were conceived according to the documents - considerably earlier and then abandoned, to be taken up again only much later. Here, in fact, the positioning of the figures is still Mannerist in type, but is not yet accompanied by the unmistakable pictorial touch of the later years, built up as it is upon changing effects of light.

The period around 1575 saw the delivery of other works which, for various reasons, had remained in Titian's studio over a long period of time: the Faith Adored by Doge Antonio Grimani in the Ducal Palace (No. 466), which recent restoration has returned to its wonderful intensity revealing passages by the artist's own hand, more particularly in the figure of the Doge; the Religion Succoured by Spain in the Prado (No. 470). altered from a previous allegory of Vice and Virtue, in which the complex, sensual forms seem to refer back to models of his youth. although these are taken up and retouched in the distinctive colour range of Titian's 'magical Impressionism'. The other paintings which conclude the catalogue of Titian's work must have belonged to the last months, if not weeks, of his life. At this point, while Venice suffered the horror of the plague, which was soon to enter his own house to carry off his beloved Orazio, we may imagine the old artist still obstinately going to his studio. Once again, perhaps, he may have taken down from the walls the canvasses of the St Sebastian now in Leningrad (No. 472), the Marsvas now in Kromeriz (No. 473), the Nymph and Shepherd in Vienna (No. 475), the mysterious Boy with Dogs in Rotterdam (No. 474). They are all works which were to be found in Titian's legacy, whence they passed into private collections in Venice to remain there for the most part until the seventeenth century, and this suggests that they had the same origin at the same time. They have a single stylistic theme, as though they were the supreme and dreadful expression of a soul drawing to the end of its days and driven to despair by the weight of age and the anguish of the moment. The colours become dark and nocturnal, with something faintly ominous in the feeble lighting; the glimmer of the reflections seems to summon a mysterious energy from the depths of the cosmos, like some ghostly offering made to the intensification of an image which was soon to fade.

The theme of light seems to recur desperately, almost symbolically in fact, in two very late canvasses: the *Christ Crowned with Thorns* in Munich (No. 478) and the *Pietà* (No. 479) in the Venice Gallery, intended by Titian to hang in the chapel of the Frari where he wanted to be buried. The light falls on the suffering Christ, as a shower of tiny drops of colour, which dissolve instantly, washed away over the surfaces, behind the shadowy folds of

the draperies, in the nocturnal depths. Light forms the figures of the last *Pietà* out of the recesses of silvery architecture vibrant with golden reflections; it clothes the green and weeping figure of Mary Magdalene and makes the marble faces of the statues grimace weirdly, like gigantic ghosts. Everything seems to quiver slowly, as though in the chromatic *largo* of some imaginary death march.

After having sketched this panorama of Titian's work, one may wonder: what remained of his artistic heritage after his death? It is difficult to define the range of Titian's influence; it was so vast and ramified. Though he did not leave a workshop, nor any real followers, he exercised a broad influence on almost all his Venetian contemporaries, from Palma to Paris Bordone and Bassano. But according to Pallucchini (1969), who has done considerable research on the subject, Titian's influence was felt particularly by foreign artists, especially in Holland and Germany, from Sustris to Calcar, Barentsz and Mor. who had the good fortune to work in Venice in his sphere of influence. Then of course one must also take into account the workshop where his brother Francesco and his son Orazio worked, followed by his grandsons Cesare and Marco Vecellio. Then there are minor figures such as Gerolamo Dente, Sante Zago and Gian Paolo Pase who have proved interesting as far as clarifying attributions is concerned, numerous spurious works having been removed from the canon (see our list of attributions). In fact, it seems that the most fruitful moment of Titian's influence was in the seventeenth century. It was then that it showed itself directly both in Venice, in minor figures such as Padovanino, ternationally, in the repeated contacts of Poussin, Rubens, Velázquez, Van Dyck and indirectly of Rembrandt with Titian's art. Many of these artists made copies of masterpieces by Titian. But most importantly, it was by this means that the Venetian emphasis on colour passed into their paintings and became a vital element in their art. This phenomenon demonstrates the perennial vitality of Titian's style, certainly the most European in Venetian sixteenth-century art: a model which survived until its reflowering in the astonishing chromatic sensuality of Renoir.

Catalogue of the Paintings

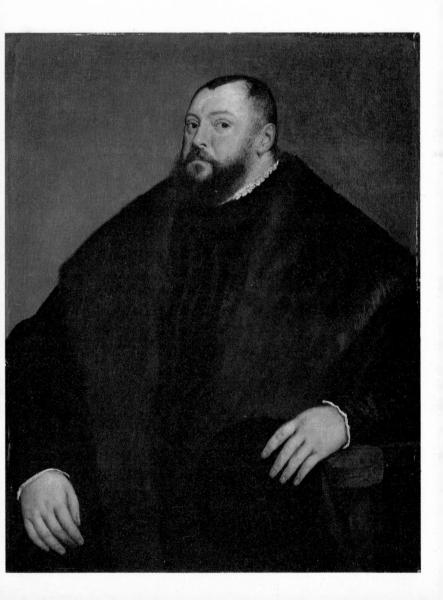

293 Venus and Cupid, with an Organist (W.III, 197) Oil on canvas/115 × 210/S./ 1548-50 Replica of No. 281 Berlin, Staatliche Museen 294 Venus and Cupid with a Partridge (W.III, 199) Oil on canvas/139 \times 195.5 With assistants Florence, Uffizi 295 Portrait of Prince Philip (V. 311) Lost: documented c. 1549 296 Ecce Homo (V. 312) Lost (letters from Titian to Granvelle 1548 to 1549) 297 Portrait of Lavinia Rangone (V. 313) Lost: documented c. 1549 298 Portrait of the Duke of Alba (V. 314) Lost: documented 1549 299 Portrait of Giuliano Gosellini (V. 315) Lost: documented 1549 300 Portraits (V. 316) Lost: documented 1549 301 Portrait of Queen Marie of Hungary (V. 317) Lost: documented 1549 302 Portrait of Catherine of Austria (V. 318) Lost: documented 1549 303 Portrait of Charles V (V. 319) Lost (letter from Titian to Ferrante Gonzaga, 1549) 304 Tantalus (V. 322) Lost: documented 1549. There is an engraving of it by G. Sanudo (Photo 304a) 305 Portrait of Pietro Aretino (V. 534) Lost: documented 1549 306 Tityus (W.III, 155) Oil on canvas/253 × 217/1549 Madrid, Prado 307 Sisyphus (W.III, 156) Oil on canvas/237 × 216/1549

DUBROVNIK POLYPTYCH

Madrid, Prado

(W.I, 168) (Nos 308A–308E) Dubrovnik, The Cathedral 308A The Assumption Oil on canvas/344 × 172/ 1549–50

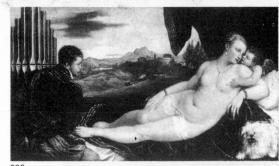

293

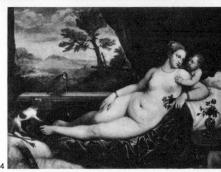

306

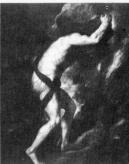

4a

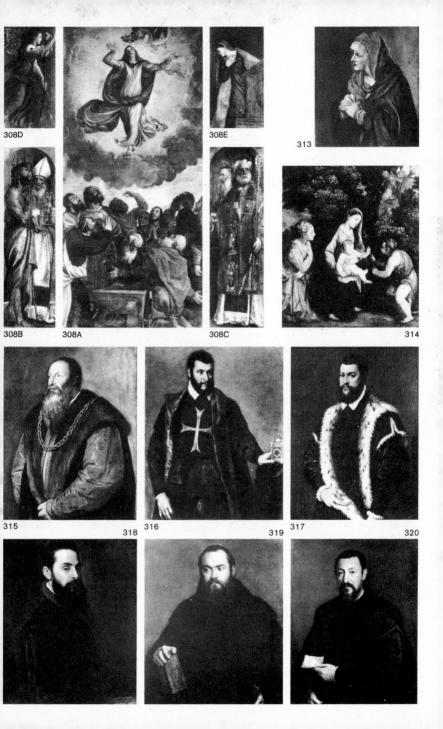

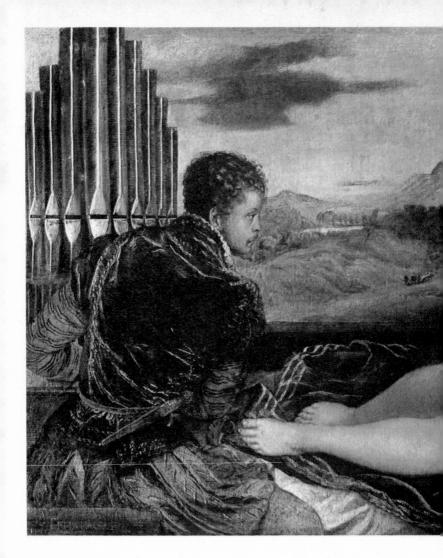

Johann Friedrich, Elector of Saxony, Seated (No. 321) (p. 11)

The Elector of Saxony, leader of the Protestants defeated by Charles V at Mühlberg, was imprisoned in Augsburg between 1548 and 1551, and Titian probably made this portrait of him during that period; it shows an impressive figure, portrayed with splendidly imposing monumentality.

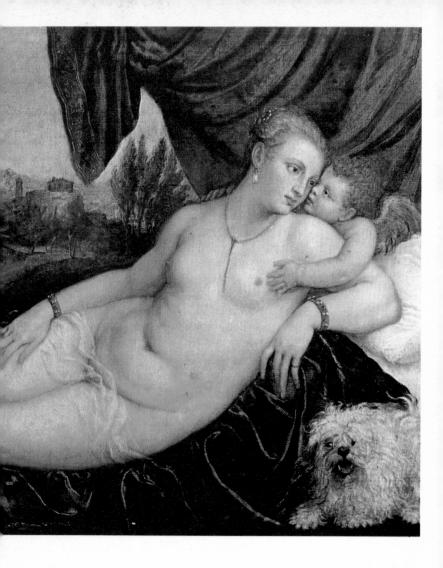

Venus and Cupid, with an Organist (No. 293) Perhaps the prototype of a subject repeated many times, this canvas dates from about 1548–50. It expressed the mood of the profoundly sensual civilization of Venice in the sixteenth century, a civilization that was often faithfully interpreted by Titian.

308B SS Lazarus and Blaise Oil on canvas/200 × 55/ 1549-50 308C SS Nicholas of Ban and Anthony Oil on canvas/200 × 55/ 1549-50 308D Angel of the Annunciation Oil on canvas/100 × 55/ 1549-50 308E The Virgin Annunciate Oil on canvas/100 × 55/ 1549-50 309 St Tiziano (W.I. 179) Oil on canvas/182 × 59/ 1549-50 Lentinai, Parish church 310 Self-portrait (V. 328) Lost: documented c. 1550 311 Portrait of Philip (V. 329) Lost (letter from Titian to Granvelle, 1550) 312 Portrait of Charles V (V. 330) Lost (letter from Titian to Granvelle, 1550) 313 The Mater Dolorosa, with Clasped Hands (W.I, 115) Oil on panel/ $68 \times 61/1550$ (?) Madrid, Prado 314 Madonna and Child Receiving the Cross from the Infant John the Baptist and St Catherine (P. 295) Oil on canvas/95 \times 87/c. 1550 Milan, private collection 315 Portrait of Pietro Aretino (W.II, 76) Oil on canvas/99 \times 82/c. 1550 New York, Frick Collection 316 Knight with a Cloak (Supposed Portrait of a Knight of Malta) (W.II, 114) Oil on canvas/122 × 101/ c.1550Madrid, Prado 317 Filippo Strozzi (incorrectly called) (W.II, 143) Oil on canvas/115.8 \times 89/ c.1550Vienna, Kunsthistorisches Museum 318 Portrait of Antonio Anselmi (W.II, 74) Oil on canvas/76 × 63.5/ s.d./1550

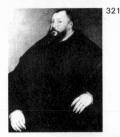

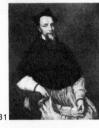

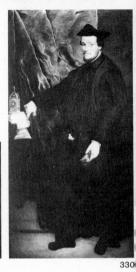

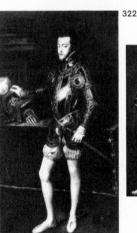

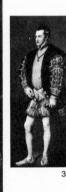

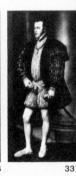

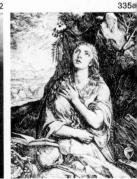

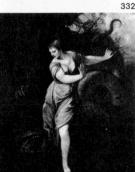

Lugano, Thyssen Collection

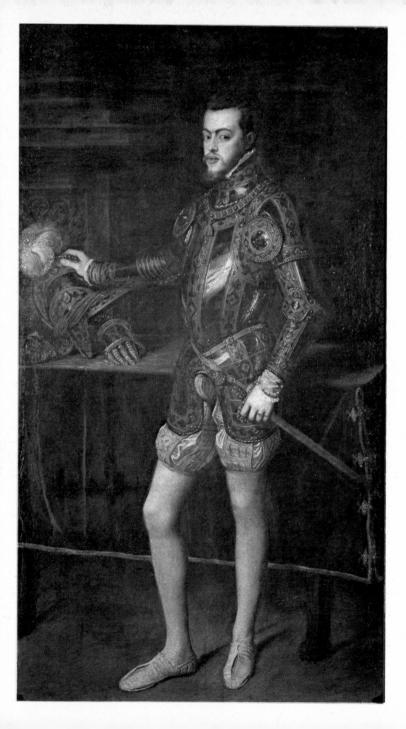

33

319 Portrait of a Franciscan Friar (W.II, 164) Oil on canvas/83.8 × 73.7/ 1550-1

Melbourne, National Gallery of Victoria

320 Friend of Titian (W.II, 102)

Oil on canvas/ $87.5 \times 70/s$./

1550–1 San Francisco, M. H. de Young Memorial Museum 321 Johann Friedrich, Elector of Saxony, Seated (W.II, 111) Oil on canvas/103.5 × 83/ 1550–1

Vienna, Kunsthistorisches Museum

322 Philip II in Armour (W.II, 126)

Oil on canvas/193 × 111/1551 Madrid, Prado

323 Portrait of Guidobaldo II, Duke of Urbino (V. 348)

Lost: documented 1552 324 Queen of Persia (V. 546) Lost: (letter from Titian to

Philip II, 1552) 325 Landscape (V. 546) Lost (letter from Titian to

Philip II, 1552) 326 St Margaret (V. 546) Lost (letter from Titian to Philip II, 1552)

327 Christ (V. 547) Lost: documented c. 1552

328 Portrait of the Duke of Atri (V. 349)

Lost: documented 1552 329 Self-portrait (V. 350)

Lost: documented 1552
330 Cristoforo Madruzzo,

Cardinal and Bishop of Trent (W.II, 116)
Oil on canvas/210 × 109/s.d./

1552 San Paolo, Museu de Arte 331 Ludovico Beccadelli

(W.II, 81) Oil on canvas/111 × 98.5/s.d./

1552 Florence, Uffizi

332 St Margaret (W.I, 141) Oil on canvas/210 × 170/1552 (?)

Escorial, San Lorenzo 333 Portrait of Philip II (V. 353)

Lost: documented 1553 334 Portraits (V. 548) Lost: documented 1553

339

340

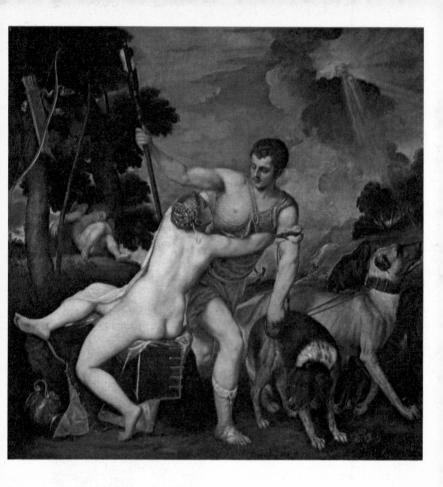

Venus and Adonis (No. 338)
Painted in 1553 for Prince
Philip, this is the prototype of
many versions of a poesia
which had a very popular
appeal, both for the sensual
theme and for Titian's dense,
fiery rendering of it.

Philip II in Armour (No. 322) (p. 17)

This was painted in 1551 in Augsburg, and is certainly the finest of the many portraits painted by Titian of Prince Philip, destined soon to succeed his father Charles V on the throne of Spain.

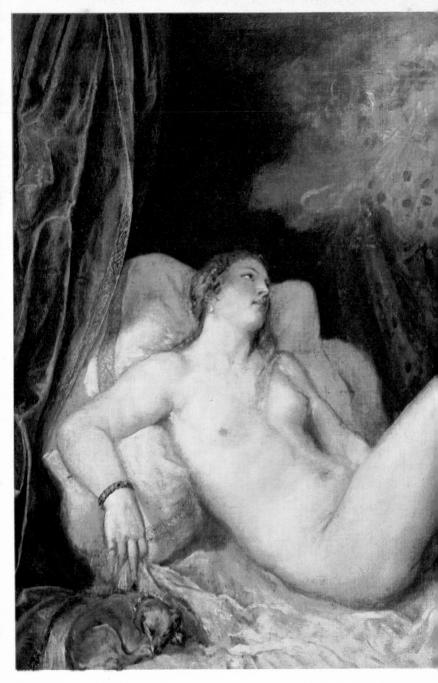

335 Mary Magdalene (V. 549) Lost: documented 1553. Engraved by C. Cort (Photo 335a) 336 Philip II (W.II, 128) Oil on canvas/187 × 100/ 1553 (?) Naples, Galleria Nazionale di Capodimonte 337 Philip II (W.II, 129) Oil on canvas/183.5 × 100.5/ c. 1553 Florence, Pitti Palace 338 Venus and Adonis (W.III, Oil on canvas/186 × 207/1553 Madrid, Prado 339 Venus and Adonis (W.III, 190) Oil on canvas/177 × 187.2 Replica of No. 338 London, National Gallery 340 Venus and Adonis (W.III, 223) Oil on canvas/187 × 184 Replica of No. 338 Rome, National Gallery 341 Venus and Adonis (W.III, Oil on canvas/157.5 × 200.7 Replica of No. 338 Somerley, Ringwood, Earl of Normanton Collection 342 Danaë with the Shower of Gold (W.III, 133) Oil on canvas/128 × 178/1553 Madrid, Prado 343 Danaë (W.III, 210) Oil on canvas//119.5 × 187 Variant of No. 342 Leningrad, The Hermitage 344 Danaë with Nurse (W.III, 135)

Oil on canvas/135 \times 152/s. Variant of No. 342 Vienna, Kunsthistorisches Museum 345 Venus at her Toilet, with two Cupids (W.III, 200) Oil on canvas/124.5 × 105.5/ 1553 - 4Variant in Cologne Washington, National Gallery of Art 346 Venus Alone at her Toilet (W.III, 222) Oil on canvas/115 × 67/s./ 1553 - 4With assistants Venice, Ca' d'Oro

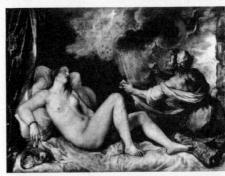

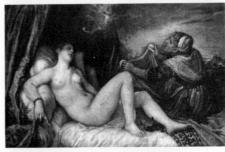

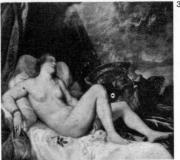

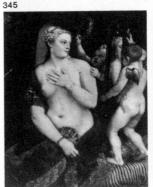

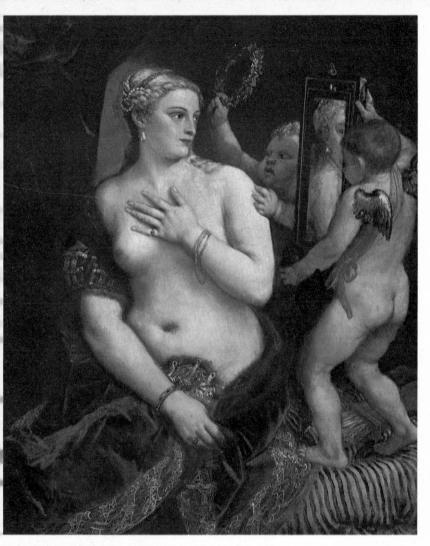

Danaë with the Shower of Gold (No. 342) (pp. 20–21) This is a second version (with an old woman in the place of a Cupid) of the prototype

painted for the Farnese family in 1546 (No. 255). This one, which was sent to Philip in 1554, seems to be in an even more intensely sensual key, with its golden colours and broken touch.

Venus at her Toilet, with two Cupids (No. 345)

Part of the 'legacy' Titian left at his death, this painting went to Leningrad and finally to Washington. The X-ray reveals a double portrait, subsequently covered over. A masterpiece of classical beauty, soft colour and velvety textures. 347 Venetian Girl (W.II, 186) Oil on canvas//98 × 74/ 1553-4 Washington, National Gallery of Art 348 Lavinia (so-called), as Bride, with a Fan (W.II, 114) Oil on canvas/102 × 86/ 1553-4 Dresden, Gemäldegalerie 349 Lavinia (so-called), with a Tray of Fruit (W.II, 115) Oil on canvas/102 × 82/ 1553 - 4Berlin, Staatliche Museen 350 'Noli me tangere' (W.I, Oil on canvas/68 × 62/1553-4 Fragment Madrid, Prado 351 The Mater Dolorosa, with Raised Hands (W.I, 115) Oil on marble/ $68 \times 53/s$./ c. 1554 Madrid, Prado 352 Adoration of the Trinity (Gloria) (W.I. 165)

Oil on canvas/346 × 240/s./

c. 1554 Madrid, Prado

Venetian Girl (No. 347)
Believed to be a portrait of
Titian's daughter Lavinia, this
canvas is an unprecedented
harmony of golden and green
silks and of singular elegance.
The young face, painted in
delicate brushstrokes, emerges
from amid the silks.

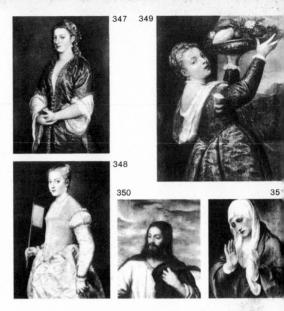

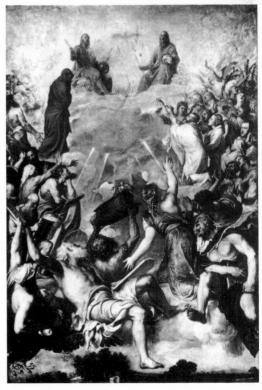

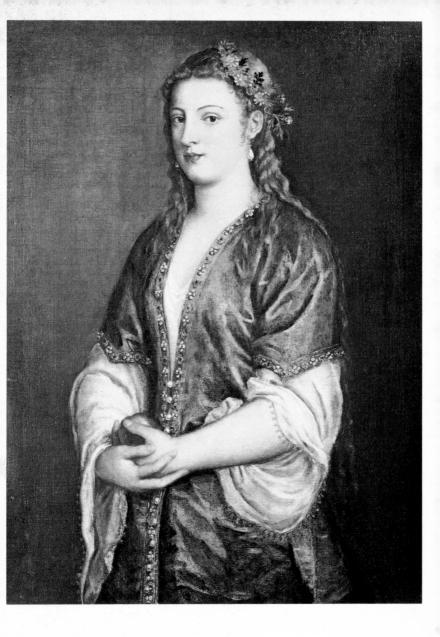

353 Apparition of Christ to the Madonna (W.I, 74) Oil on canvas/276 × 198/ c. 1554 Titian and workshop Medole, Church of Santa Maria 354 Portrait of Francesco Vargas (V. 358) Lost (letter from Titian to Charles V, 1554) 355 Doge Marcantonio Trevisan kneeling before the Madonna and Child being presented by SS Mark. Anthony, Dominic and Francis (V. 363) Lost: documented 1554 356 Portrait of Thomas Perrenot de Granvelle (V. 364) Lost: documented 1554 357 St Mary Magdalene (V. 367)

(V. 307) Lost (letter from Titian to Nicholas de Granvelle 1554) 358 Jason and Medea (V. 550) Lost (letter from Titian to Philip II, 1554)

359 A very pious work (V. 551) Lost (letter from Titian to Philip II, 1554)

360 Philip Seated, wearing a *Crown* (W.II, 129)
Oil on canvas/131.3 × 93.7/
1554-6

Cincinnati, Art Museum

361 Philip II Seated, wearing
a Cap (W.II, 130)

Oil on canvas/96 × 75 Variant of No. 360 Geneva, Kreuger Collection

362 Portrait of Archbishop Filippo Archinto (P. 302) Oil on canvas/118.1 × 94/ 1554–6 (?)

New York, Metropolitan Museum

363 Francesco Venier, Doge of Venice (W.II, 148) Oil on canvas/113×99/1555

(?) Lugano, Thyssen Collection 364 Venus (V. 368) Lost: documented, c. 1555 365 Votive painting of Doge Marcantonio Trevisan (V. 376)

Lost: documented 1555. 366 Portrait of Alfonso I (V. 378)

Lost: documented 1555

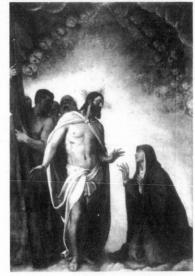

360

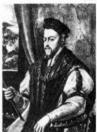

372

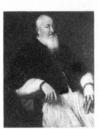

362

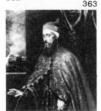

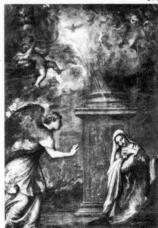

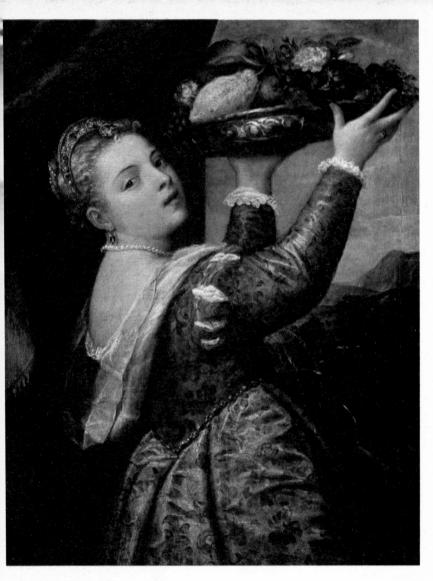

Lavinia (so-called), with a
Tray of Fruit (No. 349)
A masterly example of
Titian's most sumptuous style,
this young girl – wrongly
believed to be his daughter
Lavinia – has a hint of the last
echoes of a contrived
Mannerist pose.

367 Ercole II (V. 379) Lost: documented 1555 368 Portrait of Doge Francesco Venier (V. 380) Lost: documented 1555 369 Last Supper (V. 382) Lost (Vasari, 1568: 1555) 370 Madonna (V. 390) Lost: documented 1555 371 Deposition (V. 394) Lost: documented 1557 372 Annunciation (W.I, 72) Oil on canvas/280 × 210/s./ 1557 Naples, Church of San Domenico Maggiore 373 Pentecost (W.I, 121) Oil on canvas/570 × 260/ 1557-8 With assistants Venice, Church of Santa Maria della Salute 374 St Jerome in Penitence (W.I, 135) Oil on canvas/235 × 125/s./ 1557-8 Milan, Brera Gallery

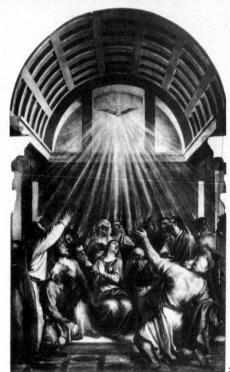

373

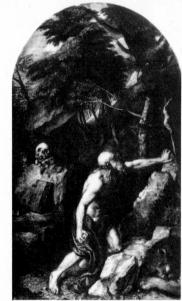

Mater Dolorosa, with Raised Hands (No. 351)

This was sent to Charles V in 1554, and has the rare characteristic of being painted on marble. To its simple colour scheme of three colours – plum, blue and white – is added intense religious feeling.

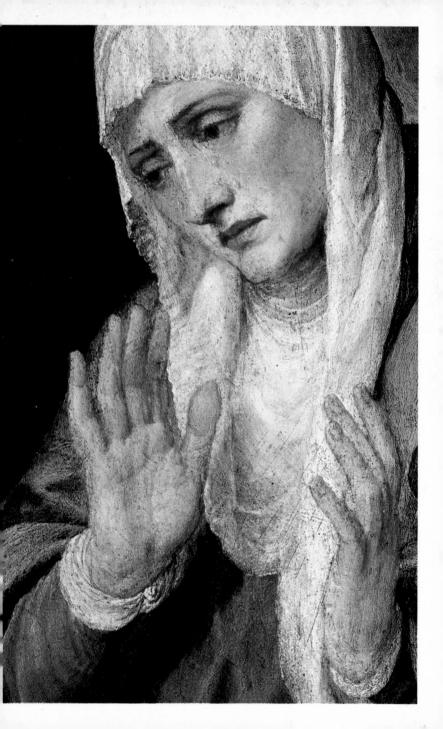

375 Fabrizio Salvaresio (W.II, 137) Oil on canvas/112 × 88/s.d./ Vienna, Kunsthistorisches Museum 376 Standard for the Confraternity of St Bernardine (V. 398) Lost: documented 1558 377 Crucifixion (W.I, 85) Oil on canvas/375 × 197/1558 Ancona, Church of San Domenico 378 Portrait of 'a young Turkish or Persian girl' (V. 404) Lost (letter from Titian to Philip II, 1559) 379 Portrait of Philip II (V.554)Lost: documented 1559 380 Martyrdom of St Lawrence (W.I, 139) Oil on canvas/ $500 \times 280/c$. 1559 Venice, Church of the Gesuiti

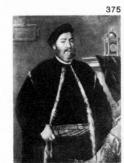

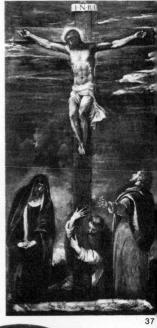

Portrait of Archbishop Filippo Archinto (No. 362) Filippo Archinto, the

ruppo Archinio, the archbishop of Milan, was in exile in Venice in 1554–5, and Titian may have painted him during those years. The picture shows a firm, monumental touch, befitting the dignity of the sitter.

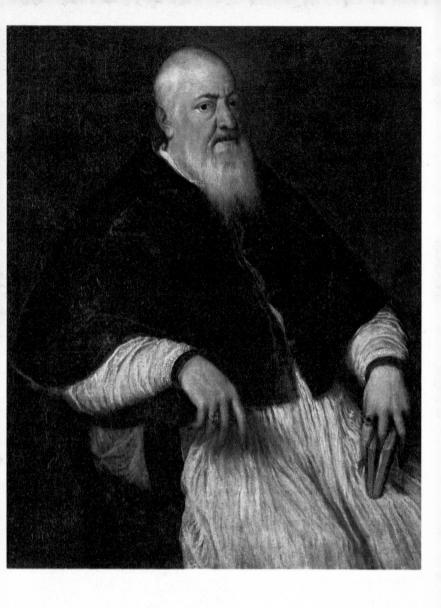

381 Ecce Homo (W.I, 87) Oil on canvas/74.9 × 59.7/ c. 1559 Dublin, National Gallery of Ireland 382 Christ on the Cross (W.I. Oil on panel/23.3 \times 17/1559 Escorial, Nuevos Museos 383 The Entombment (W.I. Oil on canvas/137 × 175/s./ 1559 Madrid, Prado 384 Adoration of the Kings (W.I. 65) Oil on canvas/138.5 × 219/s./ 1559 (?)

Variants in Madrid, Milan

Oil on canvas/112 × 213 Replica of No. 384 Cleveland, Museum of Art

and Paris
Escorial, San Lorenzo
385 Adoration of the Kings

(W.I, 66)

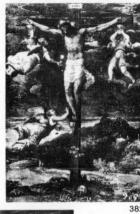

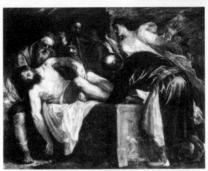

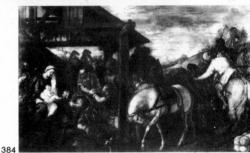

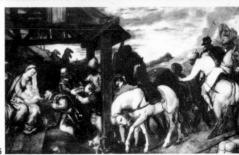

St Jerome in Penitence (No. 374; detail)

Like a sudden apparition glimpsed amid a grim landscape of crags, St Jerome clings to the rock, litby an unreal light, almost like a fire which glimmers among the trees and seems to burn the limbs of the old hermit.

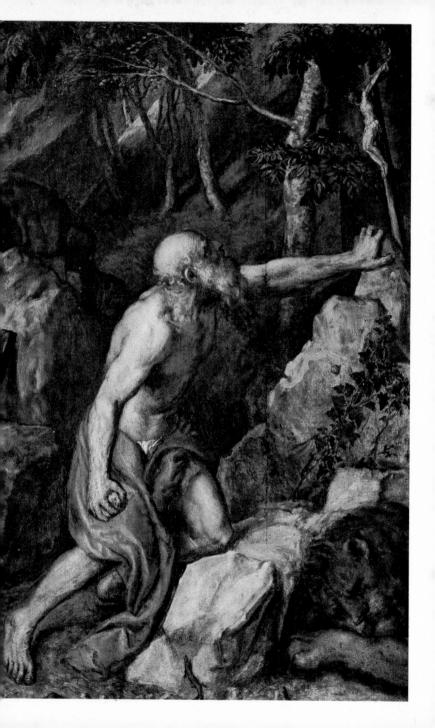

386 Diana and Actaeon (W.III, 138) Oil on canvas/190.3 × 207/s./ c. 1559 Pendant to No. 387 Edinburgh, National Gallery of Scotland 387 Diana and Callisto (W.III, 141) Oil on canvas/187 × 205/s./ c. 1559 Pendant to No. 386 Edinburgh, National Gallery of Scotland 388 St Margaret (W.I, 142) Oil on canvas/197 × 167/s./ c. 1560 Kreuzlingen, Kisters Collection 389 St Margaret (W.I, 141) Oil on canvas/242 × 182/s. Replica of No. 388

Madrid, Prado

386

Fabrizio Salvaresio (No. 375) Of all Titian's portraits, this one is outstanding for its realism. As in other paintings, the clock, here standing on the piece of furniture, signifies the relentless march of time.

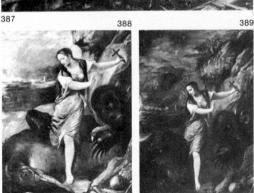

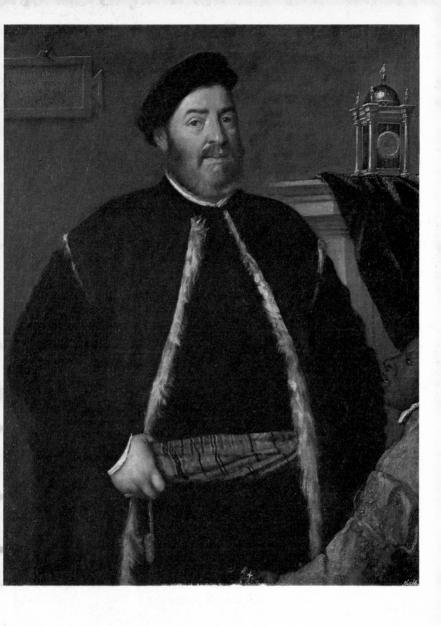

390 Wisdom (W.III, 204) Oil on canvas/169 × 169/ c. 1560 Venice, Biblioteca Marciana 391 Adoration of the Magi (V. 421) Lost (Vasari, 1568: 1560) 392 St Mary Magdalene in Penitence (W.I. 146) Oil on canvas/119 × 98/s./ c. 1560 Leningrad, The Hermitage Variants at Busto Arsizio. Genoa, Naples and Stuttgart 393 St Mary Magdalene (V. 433) Lost (Vasari, 1568: 1561) 394 St Mary Magdalene in Penitence (P. 324) Oil on canvas/109 × 94 Variant of the lost St Mary

1561 (No. 393) Malibu, Paul Getty Museum 395 Antonio Palma (W.II, 120)

Magdalene sent to Philip II in

Oil on canvas/138 \times 116/s.d./ 1561

Dresden, Gemäldegalerie 396 Niccolò Orsini (W.II, 120)

Oil on canvas/87 × 70.5/s.d./ 1561

Baltimore, Museum of Art 397 Man with a Flute (W.II, 117)

Oil on canvas/98 × 86/s./ 1561–2

Detroit. Institute of Arts

Martyrdom of St Lawrence (No. 380; detail)

One of Titian's most famous, and most tormented, paintings. After being commissioned by Vincenzo Massolo, he worked on it over a period of eleven vears. It contains Mannerist elements and reveals the influence of Titian's stay in Rome (in the background temple, not included in this detail). The main figures are inspired partly by Mannerist sentiments and are reminders of the impact of Michelangelo's work on Titian. Artificial light, from the torches and from the red coals of the fire, plays on the body and limbs of the saint.

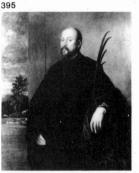

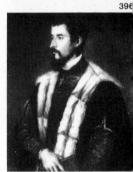

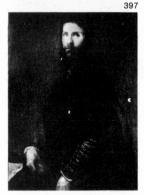

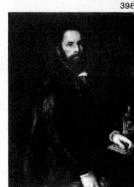

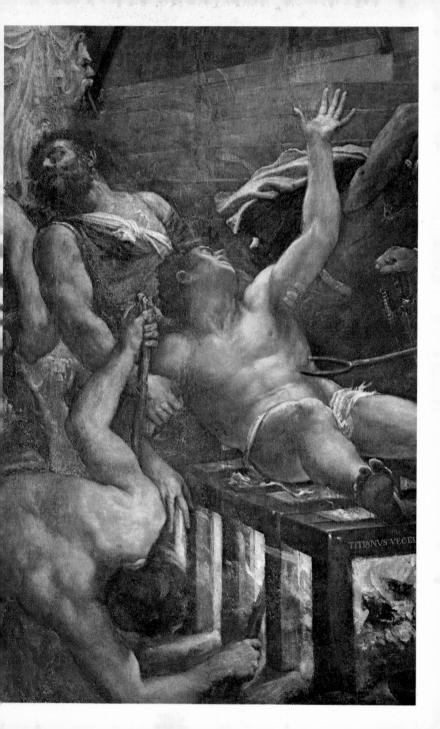

398 Antonio Galli (W.II, 165) Oil on canvas/107.5 × 84/ 1561-2 Copenhagen, Statens Museum for Kunst 399 Archbishop Filippo Archinto (W.II, 74) Oil on canvas/115 × 89/ 1561 - 2Philadelphia, J. G. Johnson Art Collection 400 Self-Portrait (W.II, 143) Oil on canvas/ $96 \times 75/1562$ Berlin, Staatliche Museen 401 Unidentified Subject (V. 555) Lost: documented c. 1562

Cambridge, Fitzwilliam Museum 403 Venus and Cupid, with a Lute Player (W.III, 195) Oil on canvas/157 × 205 Replica of No. 402 With assistants New York, Metropolitan Museum

402 Venus and Cupid, with a Lute Player (W.III, 196)

Oil on canvas/151.7 × 186.8/

c. 1562

The sinister, fiery light of the torches and coals on which the saint is being martyred lights the scene, and glimmers iridescently on the soldiers' armour.

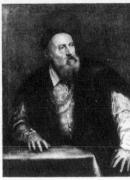

400

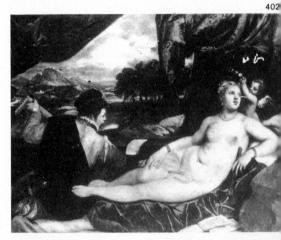

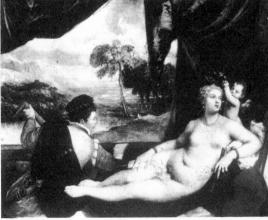

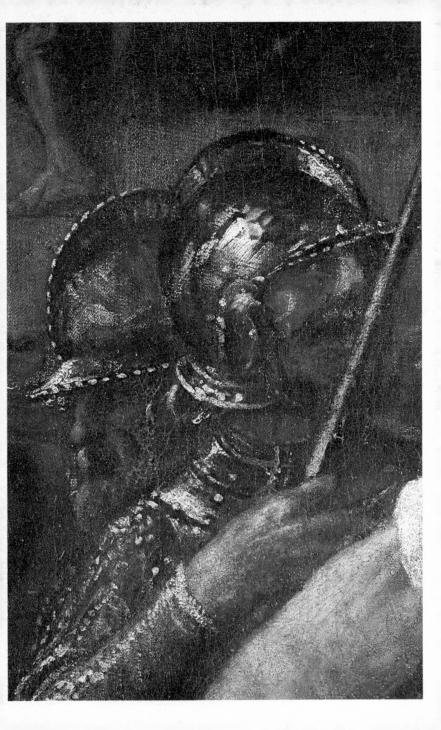

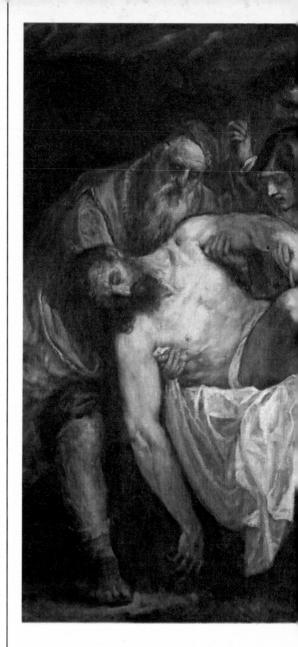

The Entombment (No. 383) Sent to Philip in 1559, this is one of the most inspired of the artist's religious compositions. As though driven by a violent whirlwind, the figures are grouped in the shadow around the body of Christ, who rises from the great white patch of the shroud. Titian painted himself in the bearded figure of St Joseph of Arimathea.

404 Venus and Adonis (W.III, 192) Oil on canvas/122 × 135.5/ c. 1562 New York, Metropolitan Museum 405 Venus and Adonis (W.III, 193) Oil on canvas/106.8 × 136 Replica of No. 404 Washington, National Gallery of Art 406 Venus and Adonis (V. 556) Lost (letter from Titian to Vecellio Vecelli, 1562) 407 Perseus and Andromeda (W.III, 169) Oil on canvas/179 × 197/ c. 1562 London, Wallace Collection

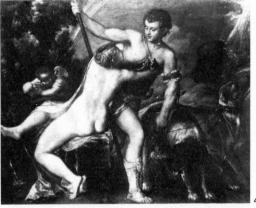

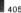

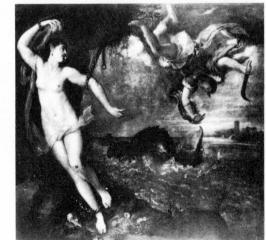

St Margaret (No. 389)
This is the last version of a theme tackled several times by Titian; it was probably painted during the 1750s. The intense, glimmering colour marks the tendency that was to become typical of his late works.

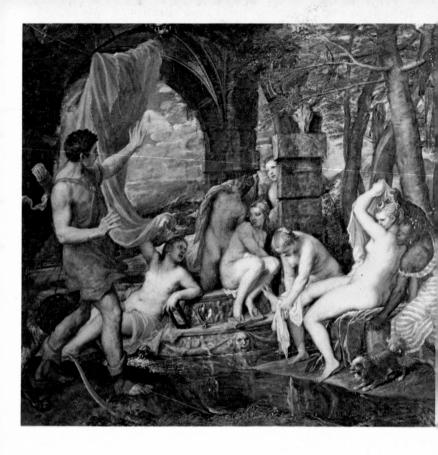

Diana and Actaeon (No. 386)
Sent to Philip II in 1559, this
great canvas marks the
beginning of Titian's last style
as it was to develop in his late
years. Though a work of his
old age, it can well bear
comparison, for its complexity
and richness of colour, with
the poesia sent thirty years
before to Alfonso d'Este in
Ferrara. Only the brushwork,
almost a short-hand with fused
strokes, is different, building
up the image by almost
magical effects of light.

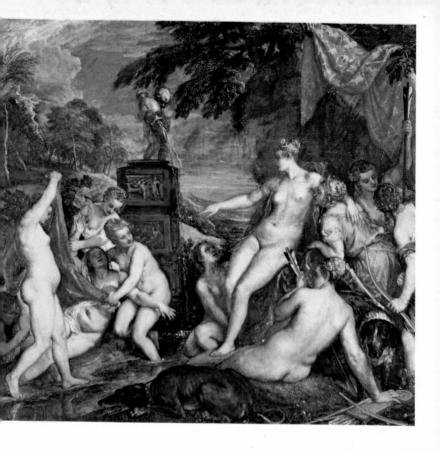

Diana and Callisto (No. 387)
I pendant to the previous
ainting, the Diana and
Callisto is a marvellously
oignant and dynamic
omposition, like a great
apestry. It is a triumph with
the bright, rich garments
orming spots of colour among
he nudes.

408 Rape of Europa (W.III, Oil on canvas/185 × 205/ c. 1562 Boston, Isabella Stewart Gardner Museum 409 Death of Actaeon (W.III, Oil on canvas/179 × 189/ c. 1562 London, National Gallery 410 Madonna (V. 557) Lost (letter from Titian to Vecellio Vecelli, 1562) 411 Agony in the Garden (W.I, 68) Oil on canvas/185 × 172/1562 Titian and workshop Escorial, Nuevos Museos 412 Agony in the Garden (W.I. 68) Oil on canvas/176 × 136/1562

Titian and workshop Madrid, Prado

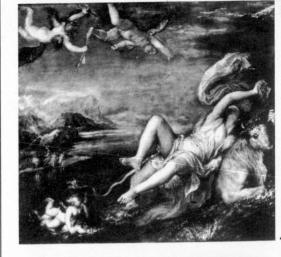

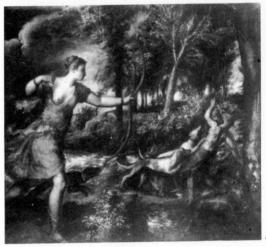

St Mary Magdalene in Penitence (No. 394)

Titian's youthful conception of the repentant Magdalene (No. 135) received various later reworkings, including this fine one in the Paul Getty Museum; her pose is firmer and her garments more clearly drawn in.

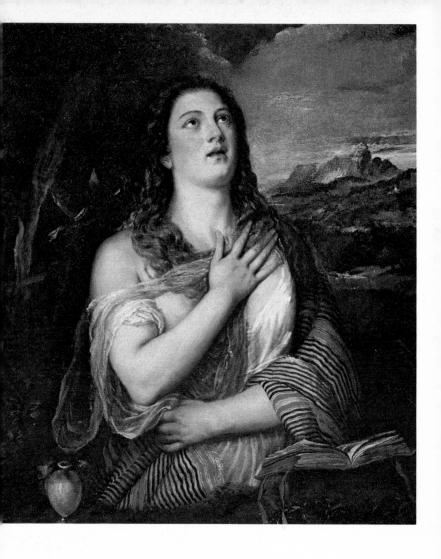

413 Madonna and Child in an Evening Landscape (W.I, 100) Oil on canvas/174 × 133/1562

Munich, Alte Pinakothek 414 St Jerome in Penitence (W.I. 136) Oil on canvas/184 × 170/s./

1562-3

Escorial, San Lorenzo 415 St Francis receiving the Stigmata (W.I, 132) Oil on canvas/295 × 178/s./ 1562 - 3

Titian and workshop Ascoli Piceno, Pinacoteca Civica

416 Christ on the Cross (W.I, 85) Oil on canvas/216 × 111/

1562 - 3Escorial, Sacristy

417 St Nicholas of Bari (W.I, 151)

Oil on canvas/171 × 91/s./ c. 1563

Venice, Church of San Sebastiano 418 Portrait of Philip II's

sister (V. 447) Lost: documented 1564

by Titian, which he saw in his studio in 1566 and which is probably to be identified with this one in Berlin. The powerful figure emerges from

Self-Portrait (No. 400) Vasari mentions a self-portrait

the shadows, amid flickering lights which virtually dissolve the forms.

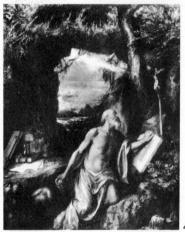

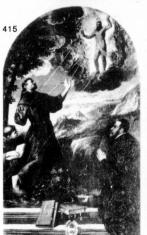

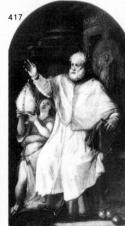

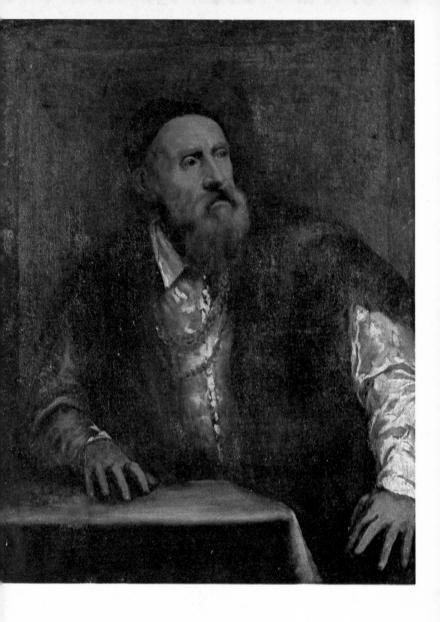

419 The Last Supper (W.I. 96) Oil on canvas/207 × 464/s./ c. 1564 Titian and workshop Escorial, Nuevos Museos 420 The Annunciation (W.I. 71) Oil on canvas/410 × 240/s./ before 1566 Venice, Church of San Salvador 421 Madonna (V. 464) Lost: documented 1566 422 Ecce Homo (V. 465) Lost: documented 1566 423 The Crucifixion (V. 468) Lost (Vasari, 1568: c. 1566) 424 Noli me tangere (V. 360 and 470) Lost (Vasari, 1568: c. 1566) 425 Laying of Christ in the Sepulchre (V. 471) Lost (Vasari, 1568: c. 1566) 426 Madonna (V. 472) Lost (Vasari, 1568: c. 1566) 427 St Paul (V. 473) Lost (Vasari, 1563: c. 1566) 428 Emanuele Filiberto, Duke of Savoy (W.II, 73) Oil on canvas/223 × 151/1566 Kassel, Gemäldegalerie 429 St John the Baptist (W.I, 137) Oil on canvas/185 × 110/ c. 1566

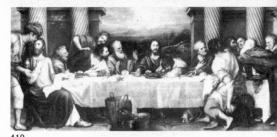

119

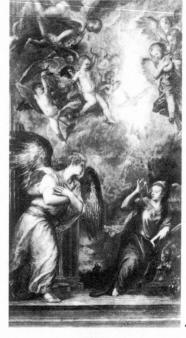

420

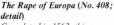

Replica in Novara Escorial, Nuevos Museos

Completed in 1562, this masterpiece was also intended for Philip II. Against a sea of greenish-blue, and a sky darkly coloured with red and purplish gleams, the half-naked figure of Europa seems dissolved by the painter's open brushwork.

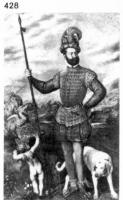

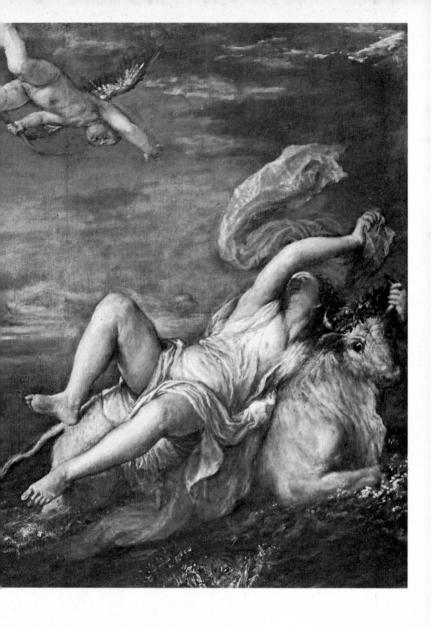

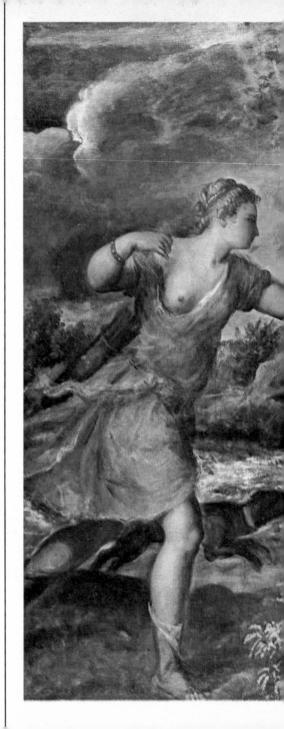

Death of Actaeon (No. 409)
Though mentioned in a letter to Philip II in 1559, when it was still being worked on in the studio, this painting was probably completed only during the following decade. The lighting of the landscape is the unmistakable proof of this.

430 Madonna and Nursing Child, with SS Andrew and Tiziano, and Titian as Donor (W.I, 103) Oil on canvas/100 × 140/ 1566 (2) Pieve di Cadore, Parish Church 431 Madonna Nursing the Child (W.I, 101) Oil on canvas/75.6 × 63.2/ c. 1566 London, National Gallery 432 The Entombment (W.I. Oil on canvas/130 × 168/s./ 1566 (?) Madrid, Prado 433 Frescoes for the Parish Church at Pieve di Cadore (V. 475) Lost: documented 1567 434 Nude Venus (V. 479) Lost (letter from Titian to Philip II, 1567) 435 Madonna (V. 480) Lost (letter from Titian to the duke of Urbino, 1567)

436 Martyrdom of St Lawrence (W.III, 263) Oil on canvas/175 × 172/

Escorial, San Lorenzo

c. 1567

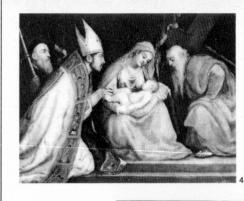

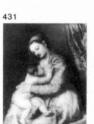

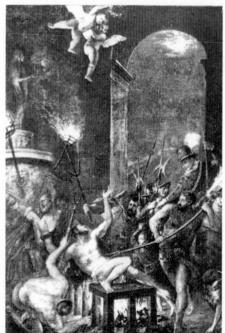

Madonna and Child in an Evening Landscape (No. 413) In 1562 Titian informed Philip It that he had sent him a Madonna and Child, which could be this one now in Munich. The figure of Mary emerges sofily from the haze of a hot, dusky landscape, her dress transmuted by light into cloth of gold.

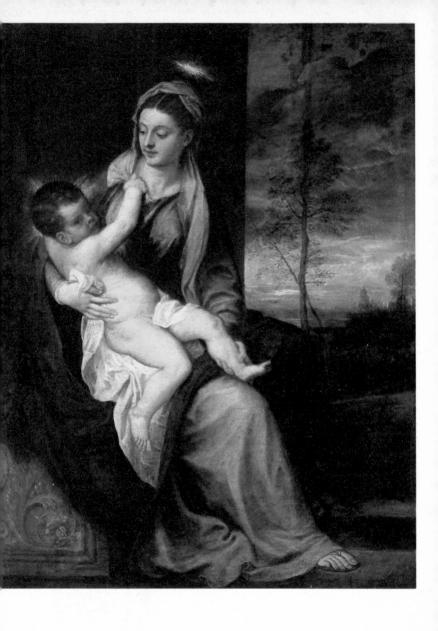

437 St Catherine of Alexandria in Prayer (W.I, 129)

Oil on canvas/119 × 99.5/1567

Boston, Museum of Fine Arts 438 Cupid Blindfolded (W.III, 131)

Oil on canvas/118 × 185/ 1567–8

Rome, Borghese Gallery **439** Cupid Blindfolded (W.III, 207)

Oil on canvas/122.4 × 97.3/ 1567–8

Partial replica of No. 438 Washington, National

Gallery of Art 440 Salome (P. 318) Oil on canvas/114×96/

1567–8 Switzerland, private collection

441 Judith (W. I, 95) Oil on canvas/112×93/

1567–8 Detroit, Institute of Arts 442 Salome (W.I, 160)

Oil on canvas/87 × 80/1567–8 Madrid, Prado 443 Lavinia as Matron (?)

(W.II, 116) Oil on canvas/103 × 86.5/s.

(?)/1567–8 Dresden, Gemäldegalerie

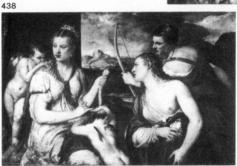

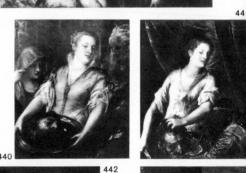

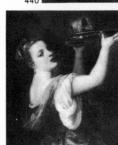

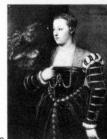

The Annunciation (No. 420)
This painting was seen by
Vasari in 1566, and cannot
have been painted much before
that date. Vibrant with light, it
has all the features of what has
been called the 'magical
Impressionism' of the late
Titian.

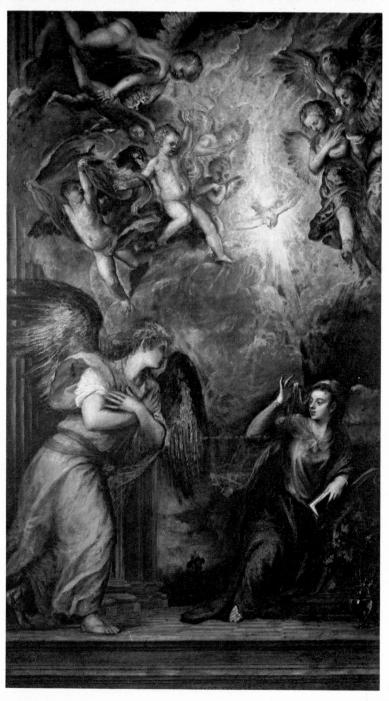

444 Paintings for the Town Hall of Brescia (V. 481) Lost: documented 1568. There is a drawing of them, Brescia, Minerva and Mars (Photo 444a), attributed to Rubens, London, British Museum; and an engraving, Forge of the Cyclops by C. Cort (Photo 444b) 445 Mary Magdalene (V. 482) Lost (letter from Titian to Cardinal Farnese, 1568) 446 St Catherine (V. 483) Lost (letter from Titian to Cardinal Farnese, 1568) 447 Death of St Peter the Martyr (V. 484) Lost: documented 1568. Engraved by Bertelli (Photo 447a) 448 Allegory of Religion (V. 485) Lost (letter from Titian to Maximilian, 1568) 449 Seven mythological 'Fables' (V. 486) Lost: documented 1568 450 Jacopo Strada (W.II, 141) Oil on canvas/125 × 95/s./ 1568 Vienna, Kunsthistorisches Museum 451 St Dominic (W.I, 131) Oil on canvas/ $92 \times 78/c$. 1568 Rome, Borghese Gallery 452 Christ Blessing (W.I, 77) Oil on canvas/96.5 \times 80.5/ c. 1568 Leningrad, The Hermitage 453 Ecce Homo (W.I, 87) Oil on canvas/73 \times 60/c. 1568 Sibiu, Muzeul Brukenthal 454 Ecce Homo (V. 463) Oil on canvas/95 \times 89/c. 1568 Leningrad, The Hermitage

Emanuel-Filiberto, Duke of Savoy (Wethey: Giovanni Francesco Acquaviva d'Aragone, self-styled Duke of Atri) (No. 428) Identification of the figure has

Identification of the figure has made it possible to date this impressive portrait to the last decade of Titian's life. In a great splash of colour, the costume stands out against the broadly painted,
'Impressionistic' landscape.

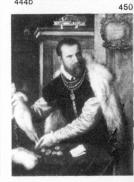

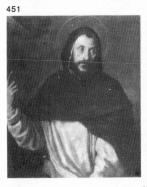

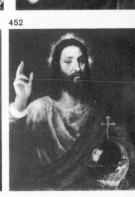

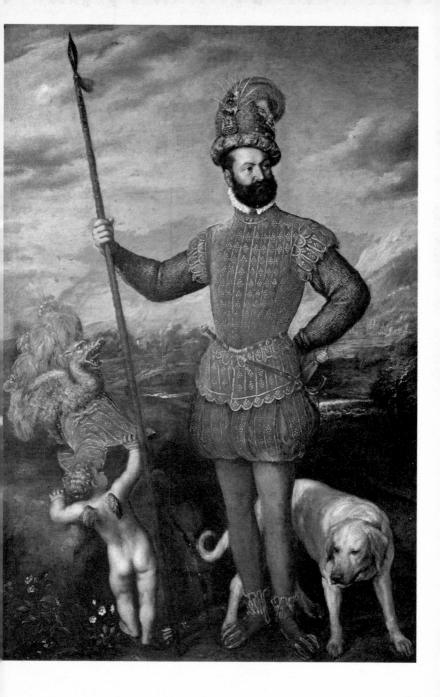

455 Christ carrying the Cross (W.I. 81) Oil on canvas/67 × 77/s./ c. 1568 Madrid, Prado 456 Christ carrying the Cross (W.I. 81) Oil on canvas/ 69.5×59.8 / c. 1568 Leningrad. The Hermitage 457 The Tribute Money (W.I. 164) Oil on canvas/109 × 101.5/ 1568 (?) London, National Gallery 458 Self-Portrait (W.II, 144) Oil on canvas/86 × 65/ 1568-71 Madrid, Prado 459 Tarquin and Lucretia (W.III, 220) Oil on canvas/114 × 100/ 1568-71 Vienna, Gemäldegalerie der Akademie der bildenden

Künste 460 Tarquin and Lucretia

(W.III, 180) Oil on canvas/188.9 × 145.5/ 1571 (?) Cambridge, Fitzwilliam

Museum 461 Tarquin and Lucretia (W.III, 181) Oil on canvas/193 × 143

Variant of No. 460 Bordeaux, Musée des Beaux-462 The Temptation of Adam

and Eve (W.I, 63) Oil on canvas/240 × 186/s./ 1571 - 5

Madrid, Prado 463 St Jerome in Penitence

(W.I, 135)Oil on canvas/137.5 \times 97/

1571-5 Lugano, Thyssen Collection 464 Stoning of St Stephen (W.I, 157)

Oil on canvas/194 × 121/ 1571 - 5

Lille, Musée des Beaux-Arts 465 St Margaret (W.I, 178) Oil on canvas/116.5 × 98/ 1571-5

Florence, Uffizi

466 Faith Adored by Doge Antonio Grimani (W.I, 93) Oil on canvas/365 × 560/ c. 1555-75

Completed by Marco Vecellio Venice, Palazzo Ducale

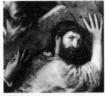

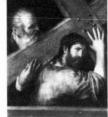

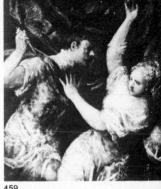

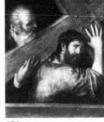

456

457

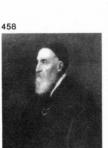

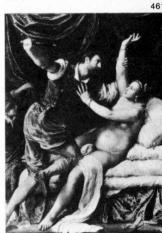

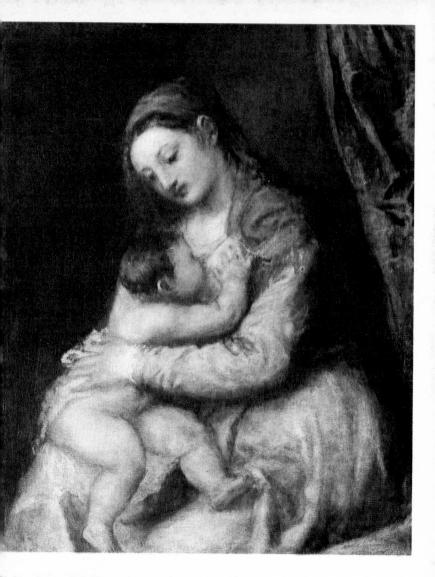

Iadonna Nursing the Child No. 431)

haded indoor settings or atural landscapes without such light seem to have spired Titian mainly towards ee end of his life. In this ondon Madonna, the forms he hazy, defined only where light glances upon them. 467 Venus's Toilet (V. 507) Lost (letter from Titian to Philip II. 1574) 468 Nativity (V. 508) Lost (letter from Titian to Philip II, 1574) 469 St Jerome (V. 510) Lost: documented 1575 470 Religion Succoured by Spain (W. I, 124) Oil on canvas/168 × 168/s./ c. 1575 Variant in Rome Madrid, Prado 471 Allegorical Portrait of Philip II (W.II, 132) Oil on canvas/335 × 274/s./ c. 1575 With assistants Madrid, Prado 472 St Sebastian (W.I, 155) Oil on canvas/212 × 116/ c. 1575 Leningrad, The Hermitage 473 The Flaving of Marsyas (W.III, 153) Oil on canvas/212 × 207/s./ 1575-6 Kromeriz, National Museum 474 A Boy with Dogs (W.III, Oil on canvas/99.5 × 117/ 1575-6 Rotterdam, Museum Boymans-van Beuningen 475 Nymph and Shepherd (W.III, 166) Oil on canvas/149.7 × 187/ 1575 - 6Vienna, Kunsthistorisches Museum 476 Christ Mocked (W.I, 83) Oil on canvas/110 × 93/ 1575-6 Variant in Madrid St Louis, City Art 477 Ecce Homo (W.I, 170) Oil on canvas/84 × 112/ 1575 - 6Escorial, Neuvos Museos 478 Christ Crowned with Thorns (W.I, 83) Oil on canvas/280 × 182/ 1575-6 Munich, Alte Pinakothek 479 Pietà (W.I, 122) Oil on canvas/353 × 348/ c. 1576

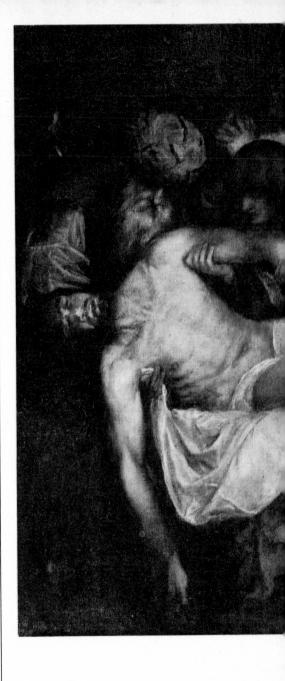

Giovane Venice, Accademia

Completed by Palma il

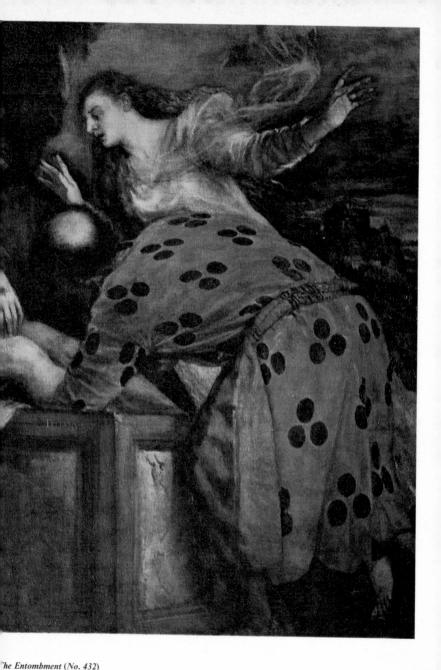

aking the composition from a canvas of the previous decade (No. 383), Titian ere presents almost the same figures, wringing from them, however, the maximum notional effect. A nocturnal, almost hunar light, mysteriously touches the figures.

480 Allegory of Prudence (Titian's Self-Portrait with Orazio and Marco Vecellio) (W.II, 145) Oil on canvas/75.6 × 68.6/ 1576 (?) London, National Gallery

OTHER UNDATED WORKS MENTIONED IN THE SOURCES

(not illustrated)

INVENTORY OF THE VENDRAMIN COLLECTION (1567-9)

481 Christ between two Executioners (V. 615) 482 Unidentified subjects (V. 541) 483 Quarrel (V. 542) 484 Christ Mocked (V. 543) 485 Portrait of a Gentlewoman (V. 544) 486 Portrait of a Gentlewoman (V. 545)

G. VASARI, 1568

487 Portrait of Francesco Filetto and his Son (V. 558) 488 Portrait of Cardinal Gonzaga, Brother of the Duke of Mantua (V. 559) 489 Portrait of Giovanni Fracastoro (V. 560) 490 Portrait of Doge Leonardo Loredan (V. 561) 491 Two Female Portraits (V. 562) 492 Portrait of Massimiano Stampa, Commander of the Castle in Milan (V. 563) 493 Portrait of Nicolò Zeno (V. 564) 494 Portrait of a Gentlewoman (V. 565) 495 Portrait of Francesco Sforza, Duke of Milan (V. 567) 496 The Virgin Annunciate (V. 568) 497 The Flagellation of Christ (V. 569) 498 Portrait of Francesco Assonica (V. 570) 499 Rest on the Flight into Egypt (V. 571)

500 Portrait of Giovanni van Haanen (V. 572)

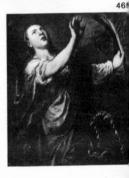

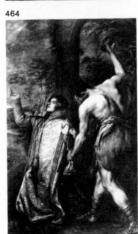

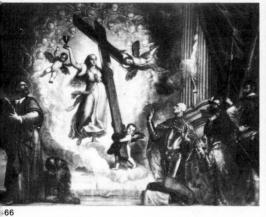

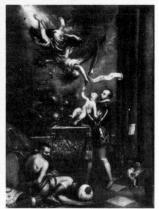

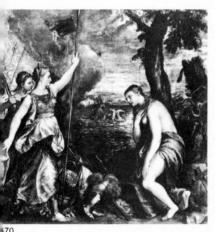

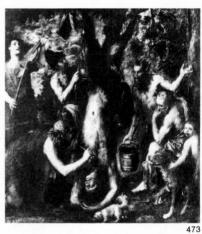

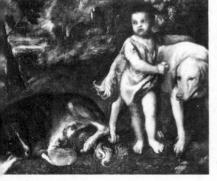

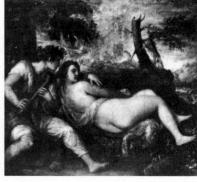

501 Madonna and Child with Members of the van Haanen Household (V. 573) 502 Portrait of Ercole II (V. 574) 503 Portrait of Cardinal Accolti of Ravenna (V. 575)

M. A. MICHIEL (HANDWRITTEN NOTE PRIOR TO c. 1575) 504 St Jerome (V. 576)

F. SANSOVINO, 1581 505 Christ Carrying the Cross (V. 578)

ARGOTE DE MOLINA, 1582 506 Self-portrait with an effigy of Philip II (V. 579)

INVENTORY OF THE ROYAL PALACE IN MADRID, 1598–1607 507 Portrait of the English Painter Juan Albin (V. 581) 508 Portrait of King Ludovic of Hungary (V. 580)

LIST OF WORKS FROM THE LEGACY OF NICHOLAS DE GRANVELLE SOLD BY FRANCESCO DE GRANVELLE TO RODOLFO II, 1600 509 Sleeping Venus and Satyr (V. 535) 510 Venus at her Toilet (V. 536) 511 Venus wearing a shift (V. 537) 512 Colossal head (V. 538) 513 Young Girl (V. 539)

PRADO INVENTORY, 1614
514 Portrait of Stanisla,
Dwarf of the court of Charles
V (V. 553)

A. SARTORI, 1821 515 Flight into Egypt (W.I, 172)

E. CICOGNA, 1853 516 Portrait of Cardinal Domenico Grimani (V. 540) 517 The Nativity (V. 577)

A. PINCHART, 1856 518 Madonna and Child (V.552)

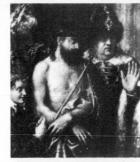

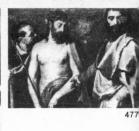

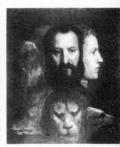

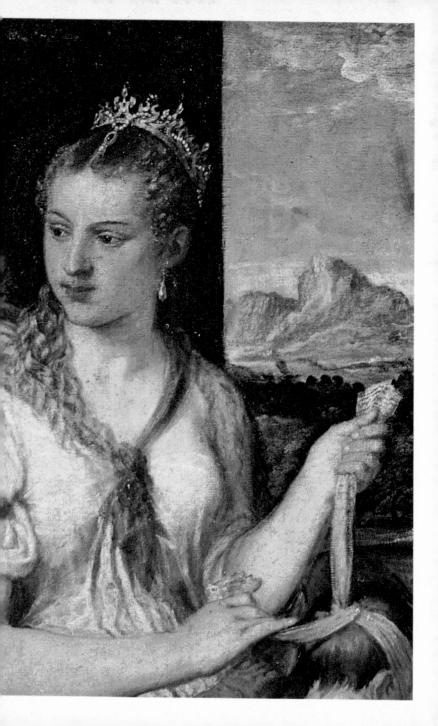

MAIN ATTRIBUTED WORKS

Attributed works are listed by collection in alphabetical order

519 Adoration of the Magi (V. 582) Oil on canvas/110 × 132 Aarburg, W. Lüthy Collection 520 Giulia di Spilembargo (W.II, 141) Oil on canvas/72 × 48 Cesare Vecellio (?) Andover, L. D. Peterkin Collection 521 Pietro Aretino (W.II, 153) Oil on canvas/58 × 46.5 Sebastiano del Piombo (?) Basle, Kunstmuseum 522 Double portrait (V. 91) Oil on canvas/87 × 102 Licinio (?) Berlin, Staatliche Museen 523 Nicholas Perrenot, Seigneure de Granvelle (W.II,

176) Oil on canvas/122 × 93 Sustris (?) Besançon, Musée des Beaux-

524 Christ on the Cross and the Good Thief (W.I, 85)

Oil on canvas/137 × 149 Palma il Giovane (?) Bologna, Pinacoteca 525 Madonna and Child, St Catherine and Infant John the

Baptist (P. 295) Oil on panel/120 × 157 Bologna, private collection 526 Landscape with Figures

(P. 324) Oil on canvas/59.5 × 81.5 Bologna, private collection 527 Gentleman with a Book (W-II, 106)

Oil on canvas/97 × 76.5 Boston, Museum of Fine Arts 528 Franciscan Friar (W.II. 164)

Oil on canvas/66 × 57 Bowood, Marquis of Lansdowne Collection

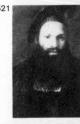

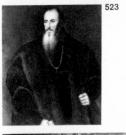

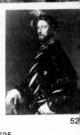

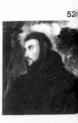

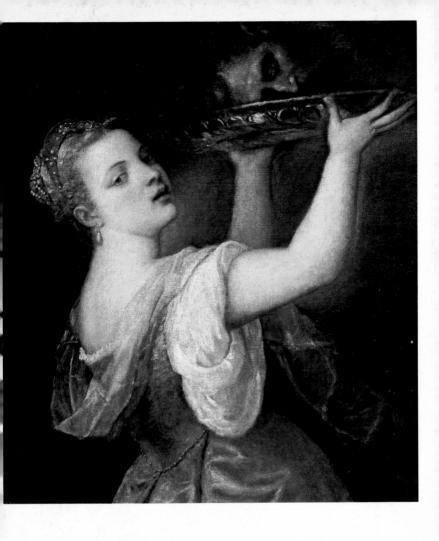

Cupid Blindfolded (No. 438; detail) (p. 67)

This scene of Venus blindfolding Cupid has only an apparent serenity. The brushstrokes, laden with stormy light, make the colour unstable and blur the design of the figures, which acquire a sense of subtle anguish, typical of Titian's late work.

Salome (No. 442) Unjustly regarded as a doubtful attribution, this Salome should be placed among the master's late works.

529 Ostension of the Holy Cross (W.I, 177) Oil on canvas/224.5 × 152.5 Moretto Brescia, Pinacoteca Civica 530 Marcantonio Trevisan. Doge of Venice (W.II, 183) Oil on canvas/100 × 86.5 Budapest, Szépműveszeti Múzeum 531 Vittoria Farnese (W.II, 162) Oil on panel/ 80×61.5 Budapest, Szépműveszeti Múzeum 532 St Mary Magdalene in Penitence (W.I, 146) Oil on canvas/105 × 92 Variant of No. 392 Busto Arsizio, Candiani Collection 533 Young Man with a Dagger (W.II, 189) Oil on canvas/97.2 × 77.2 Cariani (?) Chatsworth, Duke of Devonshire Collection Not illustrated 534 Allegory of Cupid and Venus (W.III, 207) Oil on canvas/129.9 × 155.3 Sustris Chicago, Art Institute Not illustrated 535 Danaë (W.III, 209) Oil on canvas/121 × 170 Variant of No. 255 Chicago, Art Institute 536 Giulia Gonzaga Colonna (W.H. 169) Oil on canvas/63.9 × 51.8 Chicago, Art Institute 537 Gentleman with a Dog (W.II, 168) Oil on canvas/103 × 76.2 Chicago, John Maxon Collection 538 Antonio Galeazzo Bevilacqua (W.II, 155) Oil on canvas/141.3 × 108 Cleveland, Museum of Art 539 Head of St John the Baptist (W.I, 178) Oil on canvas/50 × 75 Cleveland, Museum of Art Not illustrated 540 Venus at her Toilet with two Cupids (W.III, 201) Oil on canvas/117.5 × 101 Variant of No. 345 Cologne, Wallraf-Richartz Museum

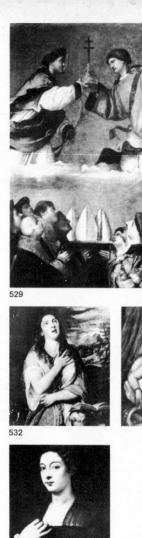

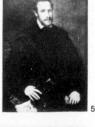

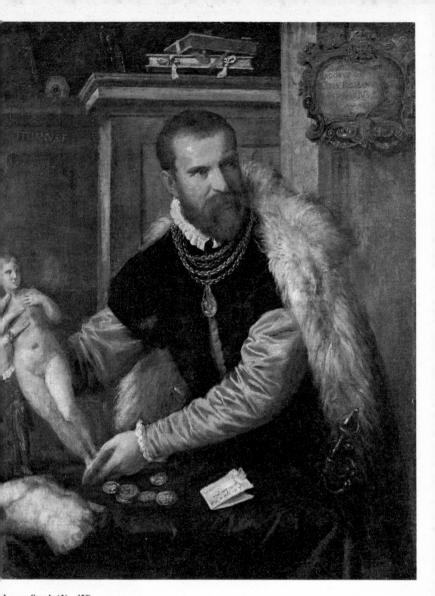

Jacopo Strada (No. 450)
Probably completed in 1568,
the portrait of the famous
antiquary Jacopo Strada is
unique in Titian's late
production, both for the
originality of the conception
and for the touch, which has
once again become careful and
deliberate in the drawing of
the face and objects in the room.

541 Nymph and Satyr (W.III, 216) Oil on canvas/99 × 80.7 Girolamo Dente (?) Detroit, Institute of Arts 542 Andrea Navagero (socalled) (W.II, 175) Oil on canvas/79 × 70.5 Detroit, Institute of Arts 543 The Appeal (Three Figures) (W.II, 152) Oil on canvas/84 × 68 Palma il Vecchio (?) Detroit, Institute of Arts 544 Madonna and Child, St Agnes and the Infant Baptist (W.I, 103) Oil on canvas/111 × 149 Palma il Vecchio, with Titian's assistance (Saint Agnes) Dijon, Musée des Beaux-Arts 545 Portrait of Gentlewoman with Vase (V. 587) Oil on canvas/99.5 × 88 Dresden, Gemäldegalerie 546 Holy Family Adored by the Donor and Members of his Household (P. 346) Oil on canvas/118 × 161 Girolamo Dente (?) Dresden, Gemäldegalerie 547 Sleeping Venus (W.III, 185) Oil on canvas/108.5 × 165 Giorgione, with Titian's assistance (Cupid and landscape) Dresden, Gemäldegalerie 548 Supper at Emmaus (W.I, 179) Oil on canvas/162 × 199 Dublin, National Gallery of Ireland

Self-portrait (No. 458) Possibly Titian's last 'formal' self-portrait, sent in all probability to Philip II during the 1570s. At that time the artist was probably already eighty years old, and he has portraved himself with merciless accuracy.

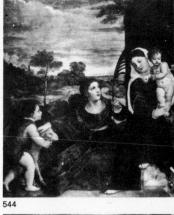

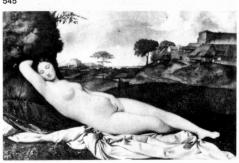

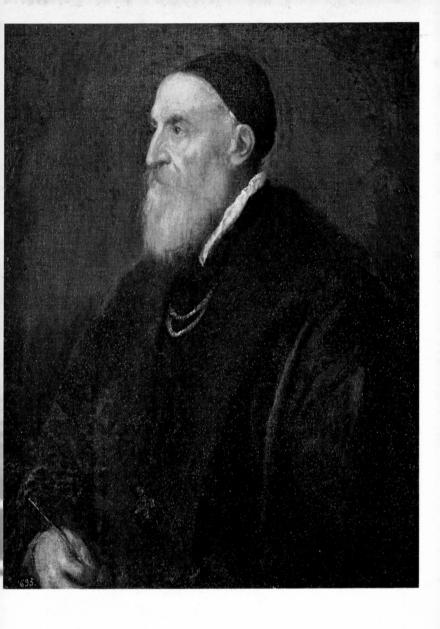

549 St Mary Magdalene with St Blaise, Tobias and the Angel, and Donor (W.I. 151) Oil on canvas/208 × 163 Dubrovnik, Church of San Domenico 550 Mathias Hofer (W.II. 170) Oil on canvas/121 x 88 Gian Paolo Pase (?) Duino, Castello Nuovo. Collection of Principi della Torre e Tassi Not illustrated 551 Venus, Mercury and Cupid (The Education of Cupid) (W.III, 223) Oil on canvas/180 × 115 Sustris (?) El Paso, Museum of Art 552 Rest on the Flight into Egypt (W.I, 125) Oil on canvas/155 × 323 Sustris (?) Escorial, Nuevos Museos 553 Madonna and Child with St Dorothy (W.I, 108) Oil on canvas/115 \times 150 Girolamo Dente (?) Philadelphia, Museum of Art 554 Resurrection (W.I. 177) Oil on canvas/133 × 82 Florence, Contini Bonacossi Collection 555 Bust of Christ (W.I. 78) Oil on panel/77 \times 57 Copy (?) Florence, Pitti Palace 556 Madonna of Mercy (W.I, 114) Oil on canvas/154 × 144 Marco Vecellio (?) Florence, Pitti Palace 557 Andreas Vesalius (W.II,

Tarquin and Lucretia (No. 459)

Oil on canvas/128 × 98 Florence, Pitti Palace

The theme of Tarquin and Lucretia occupied the ageing Titian several times (see the Cambridge and Bordeaux versions (Nos 460 and 461)). The Vienna sketch may possibly be for this latter canvas, so piercingly lifelike, with the gleams of light emphasizing the planes of colour.

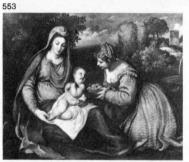

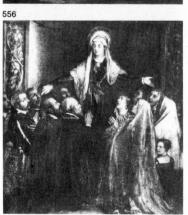

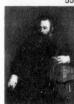

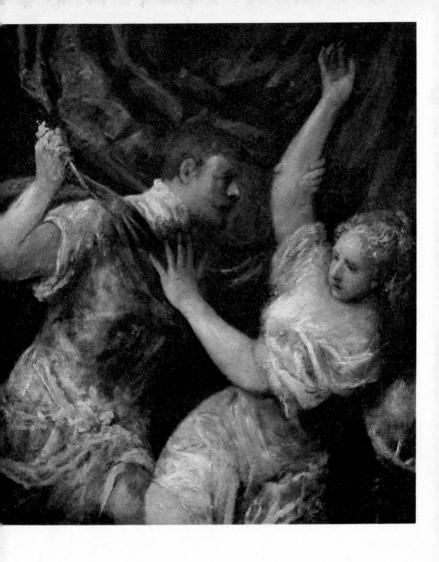

558 Diego Hurtado de Mendoza (incorrectly called) (W.II, 110) Oil on canvas/179 × 114 Florence, Pitti Palace 559 A Gentleman Seated (W.II, 168) Oil on canvas/129 × 98 Florence, Pitti Palace 560 Madonna and Child with Infant Baptist (W.I. 176) Oil on canvas/100 × 83 Marco Vecellio (?) Florence, Uffizi Not illustrated 561 Portrait of Giovanni de'Medici (W.II, 173) Oil on canvas/90 × 97 Gian Paolo Pase Florence, Uffizi Not illustrated 562 Portrait of a Senator Oil on panel/74.5 \times 59 Bonifacio Veronese (?) Florence, Uffizi Not illustrated 563 Sixtus IV (W.II, 140) Oil on panel/110 \times 90 Florence, Uffizi 564 Portrait of a Man (V. 56) Oil on canvas/81 × 60 Sebastiano del Piombo (?) Florence, Uffizi 565 St Catherine of Alexandria (W.I. 130) Oil on panel/ 102.5×72 Marco Vecellio (?) Florence, Uffizi 566 Young Man in a Red Cap (W.II, 150) Oil on panel/ 19×15 Frankfurt, Städelsches Kunstinstitut 567 St Mary Magdalene in Penitence (W.I. 149) Oil on canvas/111 × 78 Variant of No. 392 Genoa, Palazzo Durazzo-Pallavicini Not illustrated 568 An Elderly Patrician (W.II, 160) Oil on canvas/92 × 78 Genoa, Palazzo Rosso 569 A Gentleman (so-called Raphael) (W.II, 166) Oil on canvas/ 82.5×64.5 Geneva, Filiginetti Collection

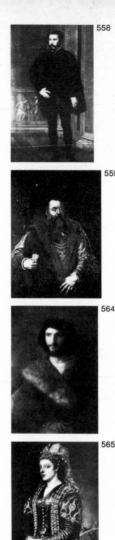

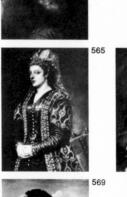

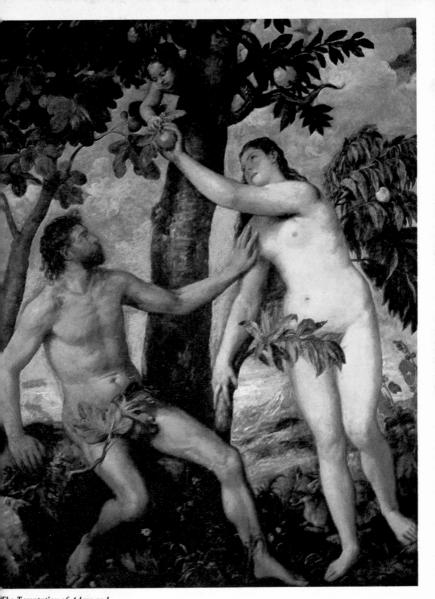

The Temptation of Adam and ive (No. 462)

In the positioning of the igures Titian was only uperficially inspired by Michelangelo. Once again he susing the coloured planes vpical of his last works, with heir subtle interplay of light and shadow.

570 Madonna and Child, with St Catherine and the Infant Baptist (W.I, 174) Oil on canvas/75.6 × 97.8 Francesco Vecellio (?) Hampton Court, Royal Collection 571 Titian, Andrea dei Franceschi and the Friend of Titian (W.II, 183) Oil on canvas/80.5 × 93 Hampton Court, Royal Collection 572 Pomponio Vecellio (socalled) (W.II, 185) Oil on canvas/107.3 × 86 Kreuzlingen, Kisters Collection Not illustrated 573 A Gentleman with a Long Beard (W.II, 167) Oil on canvas/98.3 × 74.2 Kreuzlingen, Kisters Collection 574 Andrea de' Franceschi (W.II, 164) Oil on canvas/ 86.5×68.5 Variant of No. 137 Indianapolis, G. H. A. Clowes Collection 575 A Gentleman with Flashing Eyes (W.II, 104) Oil on canvas/77.4 \times 63.5 Cariani (?) Ickworth, Bury St Edmunds (National Trust) 576 Christ Giving his Blessing (P. 274) Oil on canvas/72.5 × 65 London, Viscount Darnley Collection 577 A Gentleman (V. 71) Oil on canvas/81 × 68.5 London, Duke of Devonshire Collection 578 The Triumph of Love (W.III, 220) Oil on canvas/diam. 85 London, McKenna Collection 579 Venus and Wounded Cupid (W.III, 224) Oil on canvas/111 × 139 Francesco Vecellio (?) London, Wallace Collection 580 Giovanni Francesco Acquaviva d' Aragona (W.II, Oil on canvas/140 × 102 Lucerne, Böhler Collection 581 Cardinal (W.II, 157) Oil on canvas/111 × 91 Lucerne, private collection

78

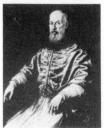

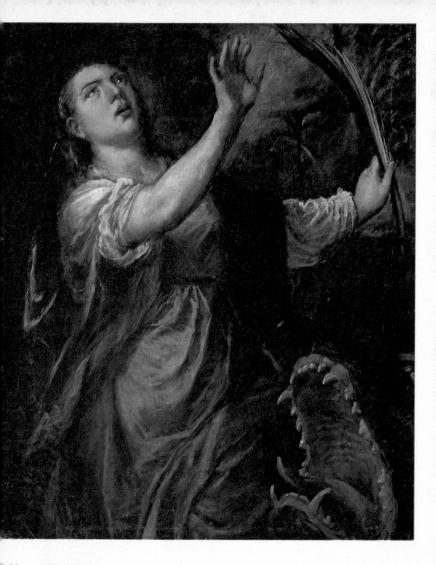

't Margaret (No. 465)
Reattributed to Titian as a sult of recent restoration, St Aargaret rises from the reenish shadow, fleeing the ra monster, to soar upwards swards the light. This late asterpiece seems to betray ome deep anxiety which has used the painter's brush to emble.

582 The Adoration of the Kings (W.I. 66) Oil on canyas/141 × 219 Variant of No. 385 Madrid, Prado Not illustrated 583 Christ carrying the Cross (W.I. 80) Oil on canvas/98 × 116 'Madrid, Prado 584 Ecce Homo (V. 499) Oil on canvas/100 × 100 Variant of No. 476 Madrid Prado 585 A Gentleman in a Lynx Collar (W.II, 168) Oil on canvas/81 × 68 Madrid, Prado 586 St Margaret (W.I, 178) Oil on canvas/116 × 91 Madrid, Prado Not illustrated 587 The Adoration of the Kings (W.I. 64) Oil on canvas/118 × 222 Variant of No. 385 Milan, Pinacoteca Ambrosiana 588 Landscape with two Satyrs and a Nymph (W.III, 214) Oil on panel/ 30.7×77.5 In poor condition Milan, private collection 589 Lady with Pearl Necklace (W.II, 172) Oil on canvas/90 × 75 Milan, private collection 590 A Warrior (W.II, 188) Oil on canvas/94 × 73.3 Milan, formerly in Chiesa Collection Not illustrated 591 Madonna and Child, with SS Francis, Jerome, and Anthony Abbot (W.I, 175) Oil on canvas/100 × 137 Francesco Vecellio (?)

Faith Adored by Doge Antonio Grimani (No. 466; detail)

Munich, Alte Pinakothek

Intended for the Sala delle Quattro Porte in the Ducal Palace, only a delay in delivery saved it from the fire of 1574. After Titian's death Marco Vecellio finished the figures on the right, but Titian's own touch has, in the recent restoration, re-emerged in the marvellous central figures.

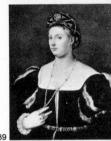

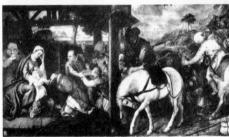

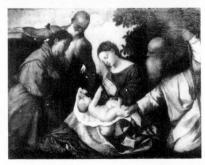

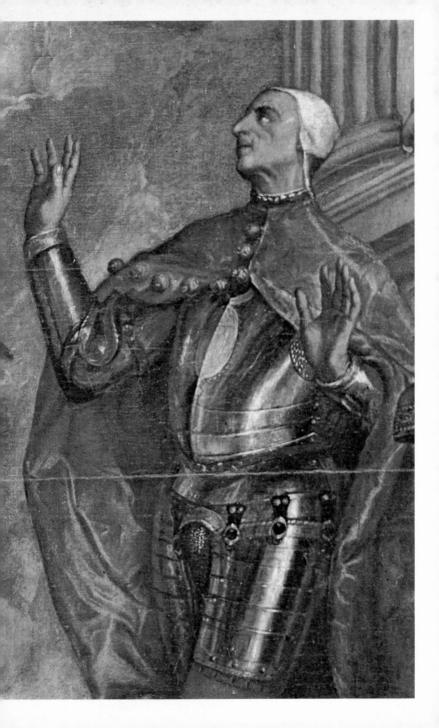

592 A Knight of Santiago (W.II, 113) Oil on canvas/139.5 \times 117.5 Munich, Alte Pinakothek Penitence (W.I, 145) 593 St Mary Magdalene in Penitence (W.I, 145) Oil on canvas/128 × 103 Variant of No. 392 Naples, Galleria Nazionale di Capodimonte 594 Portrait of Ferdinand I(?) (W.II, 157) Oil on canvas/99 × 74 Naples, Galleria Nazionale di Capodimonte 595 Pierluigi Farnese (W.II, 161) Oil on panel/ 100×75 Naples, Royal Palace 596 Guidobaldo II della Rovere, Duke of Urbino (W.II, 177) Oil on canvas/62.3 × 42.8 New Haven, Yale University Art Gallery Not reproduced 597 Danaë with Cupid (W.III, Oil on canvas/105.5 × 162.6 Variant of No. 255 New York, Golovin Collection 598 Vincenzo Cappello (W.II, 83) Oil on canvas/135 × 115 Variant of No. 193 New York, P. Chrysler Jr Collection Not reproduced 599 Father and Son (W.II, Oil on canvas/123 × 96 Padua, private collection 600 Adoration of the Magi (V. 425) Oil on canvas/217 \times 149 Variant of No. 385 Paris, d'Atri Collection Not reproduced 601 Man with a Sword (W.II, 173) Oil on canvas/99 × 82 Tintoretto Paris, Louvre 602 Madonna and Child, with SS Roch and Sebastian (W.I. 177)Oil on canvas/180 × 220 Francesco Vecellio (?) Pieve di Cadore, Parish Church

592

593

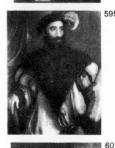

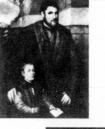

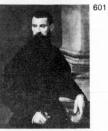

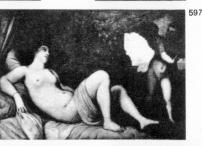

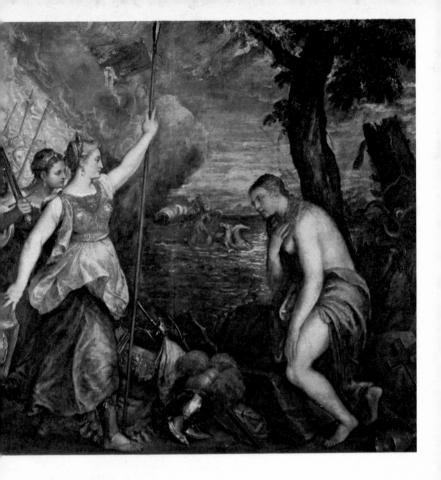

Religion Succoured by Spain No. 470) Fitian worked on a Triumph

Titian worked on a Triumph of Virtue over Vice for Alfonso, Duke of Este, which was still not completed in 1534, and indeed was never lelivered. He resumed work on it for Philip II only after 1571, transforming it into the present canvas, which combines a design from his early years with the dull glow of his late colours.

603 Madonna and Child, with the Infant Baptist (V. 23) Oil on canvas/75 × 62 Sante Zago (?) Formerly Richmond, Cook Collection

ROGANZUOLO TRIPTYCH (W.I. 112) (Nos 604A-604D) Workshop of Titian Roganzuolo, Parish Church 604A Madonna and Child Oil on canvas/240 × 80 604B St Paul Oil on canvas/190 × 57 604C St Peter Oil on canvas/190 × 57 604D Dead Christ Supported by an Angel

Oil on canvas/80 × 80 Not reproduced

605 Ippolito Riminaldi (W.II, 177) Oil on canvas/116 × 93 Orazio Vecellio (?) Rome, Accademia di San Luca Not reproduced 606 Madonna and Child (W.I, 100) Oil on canvas/122.5 × 94 Rome, Albertini Collection Not reproduced 607 Flagellation (W.I, 93) Oil on canvas/86 × 58 Rome, Borghese Gallery 608 Angel with Tambourine (V.25)Oil on canvas/98.5 \times 66.5 Sante Zago (?) Rome, Galleria Doria 609 Sacra Conversazione (V.24)

A Boy with Dogs (No. 474; detail)

Oil on panel/83 × 113 Sante Zago (?) Rome, Galleria Doria

A stormy sky seems to envelop the background of this canvas, a work of Titian's last period, in the shadows of approaching night. The colour, in a range of low tones, has a shining luminescence as if damp surfaces have been washed by recent rain.

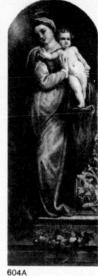

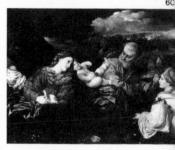

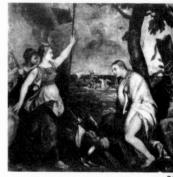

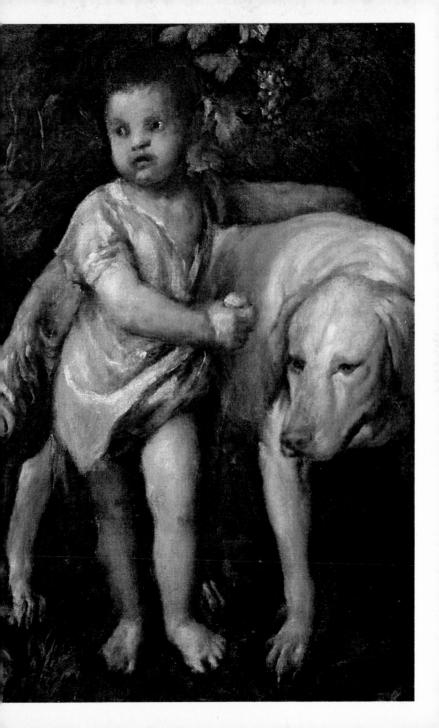

610 Religion Succoured by Spain (W.I, 124) Oil on canvas/168 × 172 Variant of No. 470 Rome, Galleria Doria 611 Philip II (W.II, 131) Oil on canvas/108 × 78 Rome, National Gallery

One of the most evocative of Titian's late works, its poetic mood touched by chill. In his last period – according to Palma's evidence – he worked impulsively, sometimes modelling the colour with his fingertips.

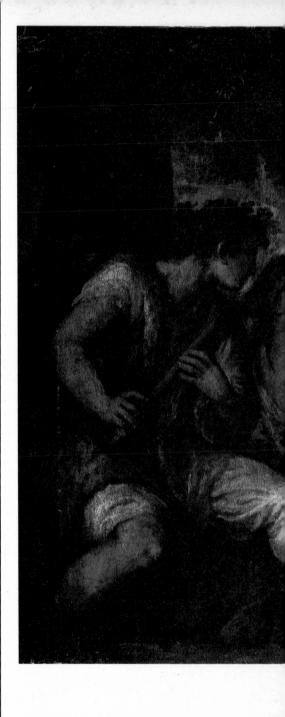

612 St Mary Magdalene in Penitence (P. 325) Oil on panel/111 \times 79 Variant of No. 135 Rome, private collection 613 Nymph and Faun (W.III, 216) Oil on canvas/ 63×53.5 Rotterdam, Museum Boymans-van Beuningen 614 Madonna and Child, with the Infant Baptist (W.I. 176) Oil on canvas/67 × 55 Francesco Vecellio (?) San Diego, Fine Arts Gallery 615 Venetian Gentleman (W.II, 186) Oil on canvas/94 × 70 San Paolo, Museu de Arte 616 Madonna and Child (P. 346) Oil on panel/172.5 \times 79.5 Francesco Vecellio (?) Sedico, Parish Church 617 St Mary Magdalene in Penitence (W.I, 146) Oil on canvas/144 × 99 Variant of No. 392 Stuttgart, Staatsgalerie 618 St Mark (W.I, 179) Mosaic/320 \times 180 Cartoon by Titian Venice, St Mark's Basilica 619 St Geminianus (V. 169) Mosaic/215 \times 90 Cartoon by Titian (?) Venice, St Mark's Basilica 620 Pope St Clement Mosaic Cartoon by Titian (?) Venice, Porch of St Mark's Basilica Not reproduced 621 Saints Mosaic Cartoons by Titian (?) Venice, Sacristy of St Mark's Basilica Not reproduced 622 Transfiguration (W.I, 163) Oil on canvas/245 × 295 Workshop of Titian Venice, Church of San Salvador

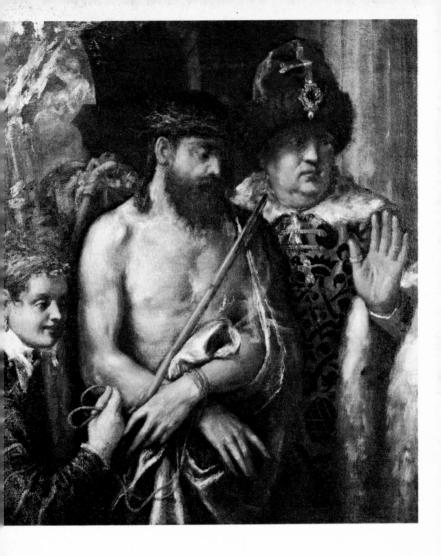

Christ Mocked (No. 476)

Titian painted numerous versions of this particularly expressive composition, of which this one, in Saint Louis, is probably the finest. Its ormented colour seems an indication of the distress of the old master.

EVANGELISTS AND FATHERS OF THE CHURCH (W.I. 120) (Nos 623A-623H) Workshop of Titian Venice, Church of Santa Maria della Salute 623A Bust of John the Evangelist Oil on panel/diam, 71 623B Bust of Luke the Evangelist Oil on panel/diam. 71 623C Bust of Mark the Evangelist Oil on panel/diam, 71 623D Bust of Matthew the Evangelist Oil on panel/diam. 71 623E Bust of St Gregory Oil on panel/diam. 71 623F Bust of St Ambrose Oil on panel/diam. 71 623G Bust of St Augustine Oil on panel/diam. 71 623H Bust of St Jerome Oil on panel/diam. 71

624 Turkish (Oriental) Potentate (W.II, 184) Oil on canvas/158 × 112 Venice, I. Brass Collection 625 Tobias and the Angel (W.I, 179) Oil on panel/172 × 147 Sante Zago (?) Venice, Accademia 626 Sacra Conversazione (P. 264) Oil on canvas/127 × 195 Palma il Vecchio. With Titian's assistance (Magdalene) Venice, Accademia

Christ Crowned with Thorns (No. 478)

With this very late masterpiece, Titian repeated a subject he had already executed thirty years earlier for Santa Maria delle Grazie in Milan (No. 230). Here the light comes only from the torch, and falls like a rain of fire on the figures glimmering in the shadows beneath.

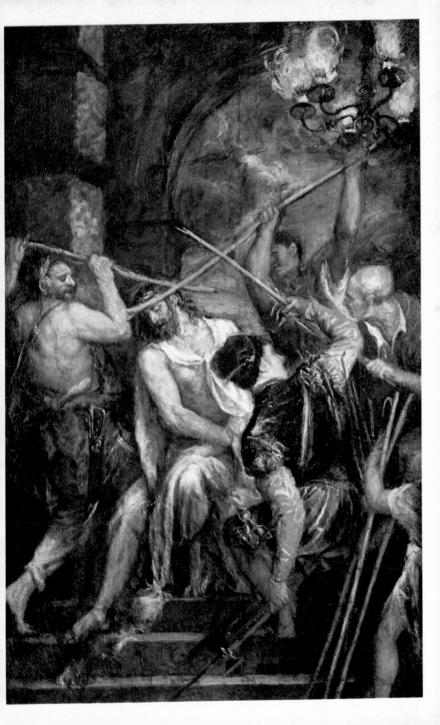

PANELS FROM THE SCUOLA DI SAN GIOVANNI EVANGELISTA (W.I, 138) (Nos 627A-627F) Workshop of Titian Venice, Accademia 627A Cupid's Heads (8) Oil on panel/39.4 × 44.5 each 627B Grotesques (8) Oil on panel/44 × 48 each 627C Symbol of Matthew the Evangelist Oil on panel/ 49.3×203.5 627D Symbol of Mark the

Evangelist Oil on panel/45.7 × 241 627E Symbol of Luke the Evangelist Oil on panel/ 46×203.5 627F Symbol of John the Evangelist Oil on panel/ 49.5×198

628 Christ Carrying the Cross (W.I, 80)Oil on canvas/70 × 100 Giorgione Venice, Scuola di San Rocco 629 Man of Sorrows (W.I, 115)

Giorgione's circle Venice, Scuola di San Rocco 630 Adoration of the Shepherds (W.I, 168) Oil on canvas/91 × 115 Vienna, Kunsthistorisches Museum Not reproduced

Oil on canvas/56 × 81

631 Christ and the Adulteress (W.I, 77)Oil on canvas/106 × 137 Workshop of Titian Vienna, Kunsthistorisches Museum

632 Diana and Callisto (W.III, 142) Oil on canvas/183 × 200 Girolamo Dente (?) Variant of No. 387 Vienna, Kunsthistorisches Museum

633 Cupid with Tambourine (W.III, 208) Oil on canvas/51.7 × 51 Francesco Vecellio (?) Vienna, Kunsthistorisches Museum

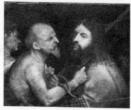

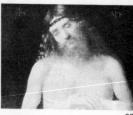

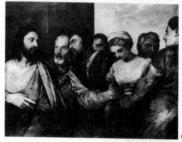

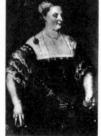

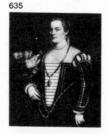

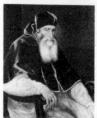

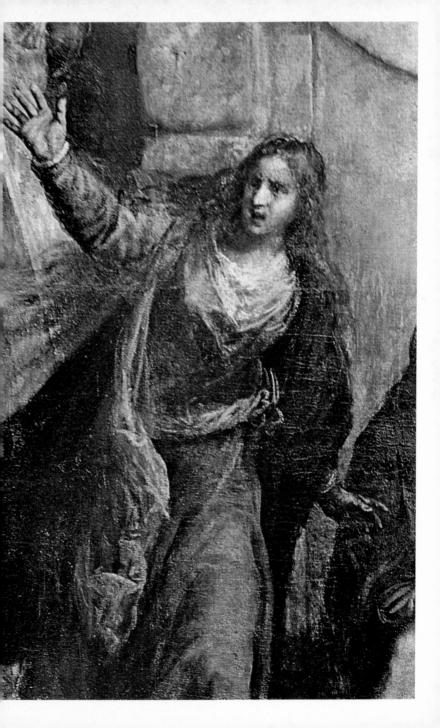

634 Caterina Cornaro (?) (W.II, 159) Oil on canvas/124 × 82 Antonio Badile (?) Vienna, Kunsthistorisches Museum 635 Lavinia as Matron (socalled) (?) (W.II, 172) Oil on canyas/111 5 × 90 Vienna, Kunsthistorisches Museum 636 Paul III with Cap (W.II, 124) Oil on canvas/89 × 78 Copy of No. 249 Vienna, Kunsthistorisches Museum 637 Bust of Christ (W.I. 79) Oil on canvas/82.5 \times 60.5 Vienna, Kunsthistorisches Museum Not reproduced 638 Madonna and Child appearing to SS Peter and Andrew (W.I, 112) Oil on canvas/456 × 270 Workshop of Titian Vittorio Veneto, Duomo 639 Cupid with Wheel of Fortune (W.III, 209) Oil on canvas/66 × 55 Washington, National Gallery of Art 640 Feast of the Gods (W.III, 143) Oil on canvas/167.5 × 185 Giovanni Bellini, with Titian's assistance for the landscape Washington, National Gallery of Art 641 Madonna and Child, with the Infant Baptist (W.I, 176) Oil on canvas/28 × 58 Washington, National Gallery of Art 642 Andrea de' Franceschi (W.II, 101) Oil on canvas/65 × 51 Variant of No. 137 Washington, National Gallery of Art 643 Emilia di Spilimbergo (W.II. 178) Oil on canvas/122 × 106 Gian Paolo Pase Washington, National Gallery of Art 644 Irene da Spilimbergo (W.H. 178) Oil on canvas/122 × 106.5 Gian Paolo Pase (?) Washington, National Gallery of Art

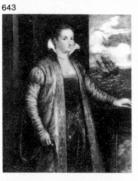

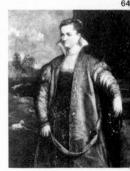

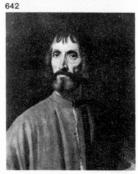

45 Venetian Gentleman W.II, 185) Dil on canvas/76 × 64 Diorgione Washington, National Gallery of Art (Kress Collection)

546 Portrait of a Lady (W.II, 172) Dil on canvas/100 × 73

Sustris (?) Location unknown Not reproduced Pietà (No. 479; detail)

Intended by Titian to decorate his tomb in the Cappella del Crocefisso in the Frari, it could not actually be placed there on the death of Titian in 1576. The Magdalene's desperate cry has a sinister ring in the light that bathes the architectural background and the ghostly statues.

Allegory of Prudence (No. 480)

According to Panofsky's interesting hypothesis, this may have been the lid of a casket belonging to Titian's household. The old artist portrayed himself on it, together with his son Orazio and his grandson Marco, as symbols of the three ages of man.

Select Bibliography

Sources

Aretino P: Lettere sull' arte di Pietro Aretino, commentary by Pertile E. and edited by Camesasca (Milan, 1960).

CICOGNA E. A.: Della iscrizioni veneziane (Venice, 1824–53).

CLOULAS A: 'Documents concernant Titien conservés aux Archives de Simancas' in Melanges de la Casa de Velázquez (Madrid, 1967, pp. 197–286).

FABBRO C: Tiziano (Belluno, 1968).

FERRARINO L: Tiziano e la corte di Spagna (Madrid, 1975).

GANDINI C: Tiziano. Le lettere (Belluno, 1977).

LORENZI G. B: Monumentii per servire alla storia del Palazzo Ducale di Venezia (Venice, 1868).

MICHIEL M. A: Notizia d'opera e di disegno, 1521–43 (edition Frizzoni, Bologna, 1884)

Pozza N: Tiziano (Milan, 1976).

RIDOLFI C: Le Maraviglie dell' Arte (Venice, 1648, edited by Von Hadeen H., Berlin, 1914–24).

Sansovino F: Venezia città nobilissima . . . (Venice, 1581).

SANUTO M: Diarii 1496–1533 (Venice, 1879–1902).

VASARI G: Le vite dei più eccelenti Pittori ... (Florence, 1568, edited by Ragghianti C. L., Milan, 1942–9).

VASARI G: The Lives of the painters, sculptors and architects . . . (English edition edited with an introduction by Gaunt W., London, 1963).

Critical Studies

Berenson B: Italian Pictures of the Renaissance, Venetian School (London, 1957).

CAGLI C., with the catalogue of Valcanover F: Tiziano (Milan, 1969).

CAVALCASELLE G. B., CROWE J. A: Tiziano, la sua vita e i suoi tempi (Florence, 1877–8) translated as Life and Times of Titian (London, 1877, 1881).

GRONAU G: Titian (English translation, London, 1904).

HOURTICQ L: La jeunesse de Titien (Paris, 1919).

LONGHI R: 'Cartella Tizianesca', in Vita Artistica (1927, pp. 216–26).

LONGHI R: 'Giunte a Tiziano' in L'Arte (1925, pp. 40-5).

Morassi A: Tiziano (Milan, 1964).

MURARO M., ROSAND D: Tiziano e la silografia veneziana del '500 (Venice, 1976).

OBERHUBER K: Disegni di Tiziano (Venice, 1976).

PALLUCCHINI R: Tiziano (Florence, 1969).

PANOFSKY E: Problems in Titian, mostly Iconographic (London, 1969).

PIGNATTI T: I disegni di Tiziano (Florence, 1979).

REARICK W. R.: Tiziano e il disegno veneziano (Florence, 1976).

SUIDA W: Tiziano (Rome, 1933).

TIETZE H: Titian (London, 1950).

Tiziano e il Manierismo Europeo, Atti del Convegno (Venice, 1978).

Tiziano e Venezia, Atti del Convegno (Venice, 1979).

VALCANOVER F: Titian (London, 1965).

VALCANOVER F: L'opera completa di Tiziano (Milan, 1969).

WETHEY H. E: Titian (London, 1969-75).

Photocredits

Museo del Prado, Madrid: p. 17, 40–1, 43, 62–3; National Gallery of Art, Washington: p. 25; Bildarchiv Preussischer Kulturbesitz (Anders), Berlin: p. 27; Metropolitan Museum of Art, New York: p. 31; J. Paul Getty Museum, Malibu: p. 47; Isabella Stewart Gardner Museum, Boston: p. 51; National Gallery, London: p. 52–3, 61, 95; Blauel, Gauting bei München: p. 55; Staatliche Kunstsammlungen, Cassel: p. 59; Scala, Antella: p. 67, 79; Editoriale Gemini, Milan: p. 81; Museum Boymans-van Beuningen, Rotterdam: p. 85; Art Museum, St Louis: p. 89.

All other colour and black and white pictures are from the Rizzoli Photoarchives.

First published in the United States of America 1981 by Rizzoli International Publications, Inc. 712 Fifth Avenue, New York, New York 10019 Copyright © Rizzoli Editore 1979 This translation copyright © Granada Publishing 1980

ISBN 0-8478-0362-7

LC 80-54044 Printed in Italy